A History of
DETROIT'S
PALMER PARK

A History of

DETROIT'S
PALMER PARK

Gregory C. Piazza

Photography by Allan Machielse
Foreword by Dan Austin

THE
History
PRESS

Published by The History Press
Charleston, SC 29403
www.historypress.net

Copyright © 2015 by Gregory C. Piazza
All rights reserved

First published 2015

Manufactured in the United States

ISBN 978.1.62619.784.8

Library of Congress Control Number: 2015936218

This work is dedicated to all who love Palmer Park

CONTENTS

Contents

FOREWORD

I t is easy, with the eyes of the world so often focused on the blight and ruins of Detroit, to overlook the beauty, landmarks and history that fill the rest of the city's 139 square miles.

Palmer Park is one of Detroit's loveliest yet most overlooked gems. For every amazing Art Deco skyscraper downtown, for every massive mansion in Indian Village, there is a stunning apartment building or house, historic fountain or gorgeous green space around Palmer Park. While other neighborhoods have lost block after block of homes, Palmer's streets have largely survived. Belle Isle gets all the fame as the city's green oasis, leaving Palmer forgotten or, in some cases, completely unknown.

That's what makes this book so important. It honors the story behind a historic neighborhood and park, the artistry behind its architecture and the legacies of Thomas and Lizzie Palmer, a couple whose significant role in Detroit's history has been largely lost to time.

Palmer is a Detroit neighborhood as strong as it is spectacular, as steeped in history as it is in mystery for the many who have never explored its streets and paths. As Detroit picks itself up and dusts itself off, Palmer Park is poised for a new era of greatness—especially now that, thanks to Gregory Piazza and Allan Machielse, the secret is out.

DAN AUSTIN, March 2015

Dan Austin is a journalist at the Detroit Free Press *and has worked at newspapers around the country. He returned to the Motor City in 2005 and ran BuildingsofDetroit.com for five years. He now tells the stories behind Detroit's renowned architecture at HistoricDetroit.org.*

Acknowledgements

First, thank you to Allan Machielse for his outstanding photography and teaching me so much about architecture.

Thank you Douglas Haller for editing and directing me to additional sources of information, to Dan Austin for introducing me to The History Press, to Dawn Eurich and the staff at the Burton Historical Library for all their help in finding information, to the staff at the Walter P. Reuther Library at Wayne State University for all their patience and willingness to assist me in research, to William Colburn and his staff for allowing me to dig through the files of the Merrill Palmer Skillman Institute at Wayne State, to the Missouri Historical Society and the Chicago Historical Society for their help on tracing the background of the Spruce Log, to Lynne Crowley of the Larchmont, New York Historical Society for her assistance and to Margaret Birrenkott and Charles Alexander for their patient editing and proofing.

INTRODUCTION

The Palmer Park Apartments National Historic District is unique among Detroit's apartment districts. A handful of well-trained architects were given the opportunity to do their best work. They respected one another's work and the discipline of their craft. The result is a lively streetscape showcasing a sense of place through a creative use of color, light and shadow and form and decoration. The district's careful use of gentle curves means the streets flow into one another and into three plaza spaces that open up the streetscape. Although the district is adjacent to a busy commercial hub, there is a sense of calm about it. Almost everyone who visits the district is taken with the careful planning and siting of the buildings. Originally, there were fifty-eight buildings, which include five houses of worship, one commercial building and fifty-two apartment buildings. The Palmer Park district is a Detroit jewel and has remained stable while similar districts in the city have decayed and vanished. While blight and decay tore apart the adjacent suburb of Highland Park (home of Henry Ford's revolutionary Model T plant), Palmer Park remained. I believe this is due to the dedication of the property owners who are personally invested in saving this community.

I came to live in Palmer Park in the spring of 1974. I was a year out of Wayne State University and had been living in the Woodbridge District, just west of the Wayne State campus in midtown Detroit. Usually it was very difficult to get an apartment in Palmer Park. Most buildings required a referral from a current tenant. I remember that I put on my best suit, got a short haircut, shined my shoes and wore a white shirt and a conservative

tie. I put together a short résumé and then went door to door in the district, meeting with managers and leaving my résumé. I completed applications, passed background checks and gave references. I finally got my first apartment at 361 Merton (Merton Manor) across the street from St. Nicholas Greek Orthodox Church. The rent was $145 per month, all utilities included, for a spacious one-bedroom apartment with hardwood floors.

The district offered a variety of living situations from efficiency apartments, to one and two bedrooms, cooperatives and two-story town houses. The rents ranged from approximately $130 for an efficiency at 750 Whitmore to $800 a month for a five-bedroom apartment at 1001 Covington. The tenants were as varied as their buildings. In 1978, I met a woman whose parents had moved into the El Dorado at its opening in 1928. She was born there and still lived in the same apartment.

As I began to explore the district, I grew more enchanted with the people (who were generally college grads), the buildings and being involved in the formation of the citizens' group the Palmer Park Citizens Action Council (PPCAC). I began to dig into the area's history and gradually developed a guide. Just south of the Wayne campus was the Canfield Historic District, composed of two blocks of late nineteenth-century homes of the district. In the mid-1970s, the City of Detroit established the first historic districts. The first area designated was Indian Village on the east side of Detroit, which had been home to many of Detroit's early business tycoons' homes.

Farther up Woodward there was the Boston-Edison Historic District, built for many of Detroit's auto pioneers (Henry Ford, the Fisher family) and business leaders (S.S. Kresge was one). I was encouraged by this group of preservationists and began my research toward getting Palmer Park a federal historic designation in 1975. That designation was awarded in 1982 but only covered buildings built prior to 1950, and about half the district was covered. Due to the siting of the buildings, some eligible buildings were left out of the district. These were added in 2005, and now all the buildings are covered by the designation.

THE EARLY YEARS

Judge Witherell

The history of the Palmer Park Apartments National Historic District and the adjacent public park begins with the 1805 arrival in Detroit of Judge James Witherell, who was the third Michigan territorial judge. Witherell was a Revolutionary War veteran in the Eleventh Regiment of Massachusetts and was with Washington at Valley Forge. He was present for the execution of the spy Major Andre. He was wounded at the Battle of White Plains. He fought at Stillwater and Benis Heights. Witherell was at the Battle of Monmouth and at Saratoga when Burgoyne surrendered. He also saw General Hull surrender Detroit to the British in the War of 1812. Hull's surrender was particularly galling, as he had asked Witherell, as a war veteran, to put together a militia to protect the city. Witherell had just completed training a band of citizen-soldiers when Hull surrendered. Witherell was probably present at the Masonic ceremony that took place in the lodge room of Detroit Zion I Lodge (founded in 1764 and still meeting today) when the American flag was trooped out of the lodge room and the British flag trooped in. His last service was at Newburgh. Given his service, his male descendants could join the Sons of the American Revolution, and the women could join the Daughters of the American Revolution. The future senator was a member of the Sons because of his grandfather's record. Witherell was also the grandfather of Thomas W. Palmer (1830–1913).

Left: Senator Thomas W. Palmer. *Courtesy of the Merrill-Palmer Archives, Reuther Library, Wayne State University. Right*: Mrs. Elizabeth Merrill Palmer. *Courtesy of the Merrill-Palmer Archives, Reuther Library, Wayne State University.*

The judge bought eighty acres of land in northwestern Greenfield Township (now northerwestern Detroit). Witherell's acreage ran from what is now Hamilton Avenue west to what is now Fairway Drive. The judge built a summer log cabin at what is now McNichols Road (Six Mile) and Log Cabin Street, which is so named because the trail ended at the cabin. Witherell left the eighty acres to his daughter, Mary Palmer, when he died in 1838, and Mary, in turn, passed them on to her son, Thomas, in 1874. As a token to remember his mother, Palmer built and endowed the Mary W. Palmer Memorial Church, Methodist Episcopal, in Detroit. This has been described as a simple chapel. The entire area where the church sat has been demolished.

Senator Palmer's parents were Thomas Palmer and Mary Amy Witherell. Thomas Palmer was born in Ashford, Connecticut, on February 4, 1789. In 1808, he and his older brother bought a wagon and a supply of general merchandise. They set out to be itinerant merchants. They went to western Canada, arriving at Malden, Canada, where they set up shop. They were fairly successful. The brothers, like all Americans in Canada, were arrested during the height of the War of 1812. They spent five months in jail and, when released, went to Detroit. Thomas arrived in Detroit on June 6, 1815. There, he and his brother operated a general merchandise store named F.&T. Palmer. The store did not survive the panic of 1824.

Thomas then invested in large tracts of land in Michigan's Upper Peninsula and a sawmill in St. Clair County (north of Detroit). In 1821, he married Mary Amy Witherell. She was born in 1795 in Fairhaven, Vermont. Her father, James Witherell, was a state legislator in Vermont and represented the state in the U.S. Congress and then was appointed judge. Judge Witherell died in January 1838. In 1829, Thomas Palmer founded the town of Palmer (now the city of St. Clair), where he opened a store and a pottery operation.

In 1818, Palmer's parents had the unique experience of being passengers on the steamer *Walk-in-the-Water*, the first steamboat to navigate Lake Erie, on its first round trip between Buffalo and Detroit and again in the fall of 1821 (their bridal tour), the ship's last trip, when it was wrecked.

2
PALMER'S ADVENTURES IN SOUTH AMERICA

Thomas W. Palmer is a significant figure in Detroit history. He was born in Detroit and moved to the village of Palmer (named for his father and now called the city of St. Clair) to Reverend O.C. Thompson's Academy. Under Thompson's teaching, Palmer studied the classic curriculum of the time—Latin, Greek, algebra and English. His essays during the three years at the academy show originality of style and composition. It was there that Palmer met David Jerome, who later defeated him for nomination as governor of Michigan.

In the fall of 1845, Palmer was accepted to the University of Michigan. He studied for one year with the thought of studying law. In 1847, he joined the Chi Psi fraternity. He dropped out of school because of a problem with his eyesight. He went to rest in the Upper Peninsula of Michigan. This helped, and he returned to his studies only to have the condition return. He was especially plagued by his eye problems between 1900 and 1910. He also complained of insomnia in that period. He tried various remedies, but the problem never completely disappeared.

In October 1848, Palmer convinced his friends David James, Cleveland Whiting, Stephen Tillotson, James Witherell (cousin of Thomas and Friend Palmer) and George Kellogg to join him on a tour of Spain and South America. They worked their way to South America aboard the *California*. It was on this trip that Palmer learned Spanish, which he and Mrs. Palmer spoke fluently. They were full of excitement as they boarded the ship, destined for Cadiz, Spain, by way of Brazil. His parents did not feel entirely

sure about this trip. Palmer wrote to his sister Sarah on October 22, 1848: "When you go home you must console Mother for my absence. Tell her that I shall be back safe sound mentally and physically." Palmer and his friends got as far as Brooklyn, where they were waiting for Mr. Tillotson. Palmer asked his parents repeatedly for a loan of either ten or twenty dollars (several days' wages in that time). He wrote that he had seen Dr. Francis, a retired physician, who, along with his wife, encouraged Palmer to take the trip.

Tillotson funded much of the cost of passage, and the others went in debt for the rest. Palmer wrote to one of his sisters (probably Mary) from New York on October 22, 1848:

> *At the southern extremity of Spain you will find an island at the mouth of Guadalquivir and on it a city, Cadiz, the oldest commercial city in the world. There I am going…We shall have a messy time roaming through the cities of Cordoba, Seville for we shall stay there in Spain, three weeks and then cross the ocean for Rio di Jainero. We shall see the fortress of Gibraltar and many of those old castles and palaces for which that country is renowned. You can have no idea of New York, its size, its many and myriad curiosities of its narrow streets filled with an interminable line of mini buses, of the men who daily throng the walks some are the embodiment of honesty and others of wealth and lastly of the varied and beautiful buildings public and the residences of the wealthy citizens. But after all I prefer Detroit to all this bustle and confusion.*

The voyage was rough, and on December 1, 1848, they landed in Cadiz. On June 27, 1849, Palmer wrote to his parents, "My eyes have perfectly recovered from the inflammation which troubled me at home…I hope we will have a good time, I hope travelling through the woods won't tire us out any. I am getting as tough as a bear and twice as black…You would laugh to see me going through the woods with a pack on my back, fighting the mosquitos, the sweat coming down in great globules." They departed on December 20 for Rio.

Palmer's cousin James Witherell wrote to their mutual cousin, Friend Palmer, from Malaga, the capital of Andalusia on the Mediterranean Sea. The letter is dated September 25, 1849. James writes:

> *There is no lack of beauty in Malaga I allow, and many freighters waste much time here for that very reason. But the charms that attracts me lies in the bay and over it floats the Star Spangled banner…I have just returned*

from Africa by way of Gibraltar. I have had a most interesting trip and come back well and well satisfied. About two weeks ago my friend and I left Gibraltar in a small Moorish boat bound to Tangiers in the Empire of Morocco. The wind was fresh and fair and the light vessel soon left Europe behind and anchored in Tangier bay and a pleasant bay it is. But there is no quay and we were carried ashore.

The letter is a bit unclear, but it seems twenty or so strong young men carried passengers as well as freight ashore. Once the group got to the city gates, they found the gates closed because it was the Muslim Sabbath and evening prayers had begun.

Finally, the group gained admittance to the city and proceeded to a small hotel, where they changed. They called on the U.S. consul, T. Hyatt, and he invited them to dinner. After dinner, he guided them through the consular garden, which was filled with grapes, pomegranates, oranges and lemons. Witherell noted that the consulate is a bit out of town and is on a hill commanding fine views. Hyatt led them through the old Moorish and Jewish cemeteries. Both were lush with flowers and trees. The swirls of color, the energy and the history were too much for Witherell to describe. He advised his cousin that if he came to Tangiers someday, he should bring a daguerreotype.

Witherell continues:

Tangiers is a sea port town of about 10,000 about half of them Sons of Israel…They are compelled to wear a peculiar dress which is calculated to give a mean appearance to the wearer…If the men look like slaves, the women look like queens. Many of them have the beautiful countenances of an intellectual cast. They wear a very gay and sometimes rich costume with gold embroidery and jewels are profusely used. Gold hoop earrings of the size of a common tea cup dangle from their ears or from the hair.

The women also wore gold-embroidered slippers and ropes of jewels and gold around their necks.

The Moors, as Witherell called them, wore white turbans, baggy trousers ending at the knee, embroidered slippers like the women, a sash around the waist and, over it all, a loose, white gown of silk with a hood. He noted that women veiled their faces outside the home. The boys visited the consul again, this time meeting his twelve-year-old daughter. She was his only family member who came with him on this assignment.

The next day, the group investigated an ancient castle just outside town. All rode spirited Arabian horses. This may have planted a seed in Palmer to raise horses. Witherell noted that a good horse was about $100 but the exportation of mares was prohibited. They explored the castle, with its battlements and cannon overlooking the harbor, and found it was the home of the "bashaw," probably meaning the "pasha."

They visited the *souk* or marketplace. It was filled with people, horses, cattle, fruit and vegetables. Their boat was filled with crated chickens that made a great mess. There was a heavy downpour as they set out for Gibraltar, but Witherell dubbed the trip a success.

There are some interesting newspaper photos of Palmer from the January 22, 1905 *Detroit Free Press* on the occasion of Palmer's seventy-fifth birthday. In one he is posed with his three sisters. The oldest, Mary Amy, was born in Detroit in 1826 and died on November 29, 1854. She married Henry Roby, a friend of her brother, on June 22, 1848. Sara Palmer, the second sister, married Henry Hubbard on November 2, 1853. He died in New York on April 28, 1871. She later married Hugh Moffat on January 27, 1879. She died on November 20, 1880. The youngest, Julia, died unmarried on November 22, 1859. While the Palmers were in Spain, Palmer's only niece—and only heir at that point, Mrs. Mary Roby Hamilton, daughter of Mary Palmer Roby—died of a congenital heart problem and pneumonia after visiting the Palmers.

Palmer was eighteen years old in the picture of him and his sisters that appeared in the *Detroit Free Press* article. He is dressed in a dark suit with a soft, high-collared shirt and a soft, draped neck cloth. In a companion photo in the *Detroit Free Press* article, he is shown at age twenty-four; the only real difference is that his face is filled out and has a more mature line to it. There is a photo of him with a grand moustache that is waxed to a pencil point style and one from 1891 on his return from Spain. He is posed with a child of about four years, who we can assume is Harold, whom Palmer had just adopted. The last picture shows him at seventy-five. Although the picture is darkened, one can see that public life has taken a great toll. The lines are deeper, and the moustache is white. The article notes he is spending his birthday at the Palmer estate in Larchmont, New York. This was one of two estates the Palmers owned on the East Coast. The other was a ten-acre estate called Oh So Cozy Little Farm, which was in Great Neck, Long Island.

There are some fragmentary journals from this period of Palmer's life. Palmer goes on at length about the lush beauty of the public gardens in Rio de Janeiro. He also mentions the lovely señoritas of the city. They were only too glad to escort Palmer around Rio. They walked the large central city

park, which was filled with flowers. They drank cool drinks as they watched the sunset. It was so relaxing that Palmer watched his ship setting off from the town pier. Palmer rented a boat and was rowed out to his ship. Palmer returned to the United States by way of New Orleans, landing there on May 1, 1849. He stayed for a while, working to pay his debts from the recent trip.

From his notes, he worked generally as a handyman, repairing doors, replacing window glass and various odd jobs, for several months. He moved from New Orleans to Baton Rouge. He stayed in Baton Rouge for nearly a year. He wrote his parents that his wages were not high, but he was making it and was confident he would make enough that he could pay off $200 in debt. In addition to handyman jobs, he worked in dry goods stores and dabbled in a little real estate. Throughout his life, Palmer would have a wide range of business interests. He had holdings in real estate around Detroit and New York City and large landholdings in western Michigan. He also had investments in a silver mining company and a gold mine in Wyoming or Utah.

Because he was only nineteen and new to the local business environment, he had to give the impression he was older. He was dealing with land transactions and other complex business deals, so he needed to instill confidence in those he worked with on these transactions. I believe it is in this period that Palmer began to hone his organizational skills and his "people skills," which would serve him well in the political arena in the future. It was in Baton Rouge that he began to earn some money. It was ten dollars here, thirty dollars over there. Not much cash from our view, but in the 1840s, these were nice sums of money. There is an ironic note in one of the fragmentary journals. It has future politician Palmer asking why anyone would want to have a life in politics. It seemed to him that it would interfere with one's home life and subject the person to undue investigation of his business.

He arrived back in Detroit for the August 7, 1852 wedding of his cousins Friend Palmer and Hattie W. Witherell. Friend Palmer would later achieve the position of general of the quartermaster corps during the Civil War.

Palmer's eye condition prevented close application or reading for long periods, so he had to abandon his idea of studying law. In May 1850, he set out on the steamer *Michigan* and landed at Green Bay, Wisconsin, where he established himself with Whitney and Company. He also had his first forays into politics. In the fall of 1850, he was elected, without his knowledge, as a delegate to the Whig county convention to be held on October 22. He was chosen secretary of the convention and then appointed delegate to the senatorial convention to be held in Manitowoc. He declined because he could not fully neglect his company.

Palmer set himself up as a merchant of general goods and speculating in flour and grain. He was succeeding when his building burned down on January 19, 1852. He had little insurance but enough to cover at least some of the loss. In Detroit in 1853, he and his father set up a company called Insurance, Land and Tax Agency, Thomas Palmer and Son. They were agents for Monarch Fire and Life Insurance Company, Irving Fire Insurance Company and Mohawk Valley Fire Insurance Company. They provided assistance with the purchase and conveying of farms, wild land and city property and payment of taxes in Michigan, Wisconsin and Illinois. They investigated titles and purchased patent titles for bounty lands in Illinois.

During this period of Palmer's life, we don't know his ideas about the business loss and his rising in political ranks because his journals, primarily from November 1850 and January 1852, were lost in an 1852 fire that destroyed his general goods company. There are fragments at the Reuther Library Archives at Wayne State University. In fragmentary journals—mostly dated from August 2, 1852, through February 9, 1855—Palmer wrote that he intended to re-create his journals from his school days to 1852. He did not restore them, and no personal journals of either he or his wife have been found in Detroit sources. He worked in the real estate business before becoming involved in lumbering and agriculture.

On October 16, 1855, he married Elizabeth "Lizzie" Pitts Merrill (1837–1916), the daughter of one of his business partners, Charles Merrill. Palmer and Merrill became partners in 1863, when Palmer became the firm's bookkeeper. He stayed in partnership with Merrill until Merrill's death on December 28, 1872. After that, the company was renamed C. Merrill and went into partnership with J.A. Whittier in Saginaw, Michigan. They managed the business for over thirty years, selling in 1903.

Palmer's political life started to move forward. Palmer gave an address before a Republican meeting, of which the papers took positive notice. In 1860, he was nearly nominated for alderman, but he was defeated by N.P. Jacobs.

Elizabeth was her father's sole heir and had become a very wealthy woman by the time she met the senator. John Brownell, writing in *Gems from the Quarry and Sparks from the Gavel*, says of Elizabeth:

> *A charming lady of rare mental acumen, choice culture and swift sympathy for the sorrows and misfortunes of others. Although for many years subjected to great physical suffering, her judicious bounties and sweet personal kindnesses have lifted sore burdens and encouraged to successful effort within and without her immediate circle. Although "born to the purple" as*

a descendant of Governors Winslow and Winthrop, through the honored New England line of Bowdoin and Pitts, her warmest and kindliest side has ever been turned to the lowly and unfortunate.

Although the illness Brownell talks about is never identified, it likely had a lot to do with the fact that the Palmers had no natural children. Agnes Burton—daughter of Clarence Burton, who founded the Burton Historical Collection housed at the Detroit Public Library—said of Elizabeth, "She was always a frail, delicate woman, but so far as her health would permit she took a keen and active interest in all of Mr. Palmer's affairs. She traveled with him, was with him while in Spain and was one of the most charming and popular hostesses during Mr. Palmer's Washington career."

Palmer expanded his inherited acreage to 680 acres (one square mile), extending from what is now McNichols Road (Six Mile) to Eight Mile to Woodward Avenue to Fairway Drive. On this land, Palmer built a large farm and raised prize Percheron and Arabian horses. The senator traveled through Europe and the Middle East, trading and selling horses, often with his farm manager, Eber Cotrell, or Elizabeth. Palmer and Cotrell met while both were serving in the Michigan state legislature.

Palmer built the Merrill Block in the 1880s in memory of his father-in-law and first business partner. It stood at East Jefferson and Woodward in downtown Detroit. It was a four-story brick building with stone trim. It boasted a large meeting hall with a small stage on the second floor. Palmer gave the architectural firm of Mason and Rice an office in the building, and he had one of his own where he could be found when not in Washington. There were stores around the ground floor. The building was demolished sometime in the 1950s.

In 1887, Palmer was instrumental in establishing the Michigan Society for the Prevention of Cruelty to Animals (now the Michigan Humane Society). Palmer served on the first board of directors and was its first president. He was a member of the Michigan senate from 1879 to 1880 and served in the U.S. Senate from 1883 to 1889. While in Congress, Palmer was known as an advocate for women's suffrage, immigration restrictions, regulation of railroads and homesteader rights. His motto was "Equal rights for all, special privileges to none." In 1873, he was elected a member of the Board of Estimates of Detroit. In 1876, he was an unsuccessful candidate to Congress. He declined another nomination to the seat in 1878. He refused a nomination for governor in 1880 as well. While in the state legislature, he was successful in passing bills to establish an institution for delinquent girls and for the sale of $700,000 to purchase Belle Isle, an island park in the Detroit

River, and for the building of a bridge over the American side channel. Belle Isle was purchased on September 25, 1879. He was nominated for U.S. senator and won that position in 1883. While in Congress, he served as chair of the Committee on Fisheries (Forty-ninth Congress) and served on the Committee on Agriculture and Forestry (Fiftieth Congress). Besides these positions, Palmer also served on the committees for post offices, post roads, the District of Columbia, transportation routes to the seaboard, commerce, women's suffrage, enrolled bills and education and labor.

Palmer was largely seen as a nineteenth-century man of the people. He was called "The Sage of the Log Cabin," which presents a picture of the wise old man dispensing wisdom from his front porch to all who sought him out. This persona was genuine, I believe, but he was not above nineteenth-century politics. In the 1883 battle for the U.S. Senate, Palmer was encouraged to run as a dark horse candidate against incumbent Thomas W. Ferry. Ferry was not popular with his colleagues. His record in Washington was undistinguished, and he had made few friends. Palmer and his supporters went into a secret group to ensure Palmer's selection. Their aim was to gradually force Ferry into awkward positions. As his position grew weaker, Palmer's agents would attempt to persuade the Ferry supporters to select Palmer. They realized it would be a battle, but they got some unexpected help. Upper Peninsula congressman Jay Hubbell disliked Ferry intensely, and this drove him to make bitter and vindictive public attacks on Ferry.

This would not guarantee Ferry's defeat, but it would rouse the party. On December 29, 1882, the *Detroit Free Press* set the pattern for the campaign against Ferry. The paper concluded that a Democrat could not defeat Ferry. But it reminded its readers that a senator represented his state and a state was judged by its senators. If a senator conveys a poor impression of the state, everyone suffers.

Palmer called attention to his availability while he maintained a pose of being a supporter of Ferry. He worked to allay fears of some in the caucus that he was really undermining Ferry. On the first ballot, Ferry led, and Palmer received nothing. As the voting continued, it was obvious that Ferry could not get a majority. Palmer wrote to a Muskegon business partner, Newcomb McGrath. His instructions were to "please organize your force and be in readiness to go to Lansing on receipt of the telegraph from Livingstone. Get some men who can influence Reed is possible so that when the break up comes as it is likely to at any time, you can bring him over to me."

Palmer was ready to come in and be elected. As the votes continued to be taken over several days, Palmer's support grew. There was a rumor that Ferry

had met financial disaster. Ferry assured the legislature that this was not the case. Palmer, meanwhile, was fighting accusations that he was working for his own nomination while pretending to be for Ferry. Palmer responded by saying he would not be a candidate until Ferry's name was off the ballot.

Rumors of Ferry's financial problems proved to be true. He had been involved in numerous business deals, the most important of which was a lumber company in Grand Haven. A failure of a silver company in Utah precipitated the bankruptcy. Ferry's financial woes continued to grow. Palmer finally won on the eighty-first ballot. In his acceptance, he said:

> My first duty I consider to be the flag of my country that flag which has been baptized in blood and consecrated by prayers. My second duty will be to my state. It will be no western district with me. I shall not be confined to southern or northern lines. The question of location shall have nothing to do with my preference for my acts. My aim will be to serve the people of Michigan faithfully.

The *Evening News* chalked up Palmer's victory as a victory for organization. Backed by loyal supporters, Palmer had been able to sit back and organize all his plans. While openly supporting Ferry, Palmer subverted and undermined Ferry's support. He emerged from political limbo to triumph in one of the most controversial and bitter political contests ever to be waged in Michigan. Palmer served one term (1883–89). For an excellent discussion of the story, I refer you to "The Eighty-first Ballot: The Senatorial Struggle of 1883" by Lawrence E. Ziewacz.

Politically, Palmer was in the mold of Teddy Roosevelt. He also had great faith in Taft. We see these ideas in a 1910 letter from Palmer to Reverend Calvin Stebbins. Palmer wrote, "Roosevelt was the storm and tempest. He has done the breaking up of the ground and now I think Taft is qualified with the readjustment of things. He seems to do everything well and in order. He has got the South in line and now will take care of the Republic. I am an optimist as you know, so I believe everything will come out right." The idea that one should use physical work to heal oneself could be applied to Palmer's own adventures spending several months hiking around Spain as is described above.

Palmer was a Unitarian, and although he embraced its ideals, he had a sharp view of religion and religious practice. He addressed these feelings in an April 1909 letter to Henrietta Seelye:

I am glad to hear that Mr. Newell is in Shanghai as this is the only way by which you can be kept from going to meetings of one kind or another five times a day…I think that while on earth that true devotional line can be better sub served [sic] by doing something in the way of practical work instead of giving so much time to religious formulas….Now going to church and prayer meeting and religious work are all good in their way, but I do not think it does you any good because you enjoy it so much. Get something you do not enjoy and go to work at it that is what will make a Christian of you. As it is your efforts are not sacrificing. You revel in it and enjoy it and therefore no good.

In other correspondence, Palmer's philosophy is very Protestant, following the "faith without works is bare" philosophy. He is tough on false piety. But it seems that as he climbed the political ladder, more people approached him for charity, as if he had some obligation to provide charity on a larger scale since he was in a position (in their minds) that required him to pay.

He was reputed to have the ability to win over strangers after talking with them for only a few minutes. A *Detroit Free Press* article from March 2, 1883, said of the senator, "Mr. Palmer is one of the most finished orators of the Republican Party in this State. He is a man of scholarly tastes, extensive reading and wide general attainments. His courtesy and hospitality are proverbial throughout the state and have in no small degree contributed to the widespread popularity which has made him Senator."

Another example of his oratory skills—a speech made on Decoration Day, May 30, 1879—is below:

Many years ago I stood upon the deck of a merchant man, in the harbor of Cadiz, in Spain, there, thank God; our flat was flying at the peak of a man-of-war. A great lump rose in my throat, great drops rolled down my cheeks. I reached out my arms as if to enfold it. What to me were the historic scences of Spain and its fables, what its olive groves and acacias what was Xeres, Saguntum, the Alhambra or the Guadalquivir? Yet, to one who knew not its significance, it was but a piece of bunting, with hues harmoniously blended not half so attractive as a painting or a landscape; but o Murillo, nor the gardens of Atlantis, could have awakened any such emotions in my breast.

Clarence Burton, in his 1922 seminal work *The City of Detroit*, which profiles prominent people (mostly men) in the city of Detroit, wrote:

Mr. Palmer's notable success as a business man resulted from his native talents, combined with the systematic improvement of every legitimate opportunity. Among his associates he was always known as a man of great resourcefulness and very direct in the execution of his plans. His career was identified with large business affairs and through his well-directed efforts he accumulated one of the largest estates in Michigan and amassed a large fortune in connection with lumbering and financial enterprises.

Burton went on to say, "Citizens of Michigan may well be proud of this financier and statesman, who continually subordinated his personal ambition to the public good and who always sought rather the benefit of others than the aggrandizement of self." Palmer was also involved in Free Masonry. He was brought to light in Masonry in Detroit Zion No. 1 on May 4, 1859, and was crowned an honorary thirty-third degree on January 28, 1892. The lodge was founded in 1764 and still meets at Detroit's massive Masonic Temple. It is the oldest Masonic lodge west of the Allegheny Mountains.

3

PALMER AND SUFFRAGE

Palmer was one of a small group of senators and congressmen who lobbied fiercely for passage of a bill ensuring suffrage for women. On February 6, 1885, he delivered the first speech given on the U.S. Senate floor arguing in favor of the Sixteenth Amendment granting women's suffrage. It was also one of the few times Palmer spoke on the Senate floor. Palmer had the conviction that if women were more involved in the political arena, the system would be better. Candidates would be vetted better, being chosen on their character rather than their connections.

He went on to say:

> *I share no fears of the degradation of women by the ballot. I believe rather it will elevate men…and that better officers will be chosen to make and administer the laws. I believe that the casting of the ballot will be invested with seriousness, I had almost said sanctity, second only to a religious observance.*

Palmer loved statistics, and in this speech he noted:

> *From the imperfect gleaning of the Tenth Census we learn that of the total enumerated bread winners of the United States more than one-seventh are women. They are classified in round terms as follows: Agriculture 600,000; professional and personal services, 1,400,000; trade and transportation, 60,000 manufactures and mechanical and mining industries, 600,000. That these 2,647,157 citizens of whom we have official information*

labor from necessity and are everywhere underpaid, is within the knowledge and observation of every Senator upon this floor.

He refuted the objections to extending suffrage:

I wish that every Senator would examine this report and note how many of its reasons are self-refuting and how few even seem to warrant further antagonism. They cite the physical superiority of man, but offer no amendment to increase the voting power of a Sullivan or to disfranchise the half, the lame, the blind, or the sick…They are dismayed by a vision of women in attendance at caucuses at late hours of the night, but doubtless enjoy their presence at routs and entertainments until the early dawn…Eloquent women are employed by State committees of all parties to canvass in their interests and are highly valued and respected.

He reminded the Senate that any woman who owns railroad, manufacturing or mining stock may vote unquestioned by the side of the best businessmen in the country, but if she transfers her property, she loses all voice in its control. He quoted the Bible, the Bill of Rights and the Constitution. In closing, he said, "Whatever may have been wisest as to the extension of suffrage to this tender and humane class, when wars of assertion or conquest were likely to be considered, today and tomorrow and thereafter no valid reason seems assignable for longer neglect to avail ourselves of their association."

Palmer was one of several in the House and the Senate who introduced bill after bill on the issue. Every attempt to pass a bill failed. On December 18, 1893, he received a letter from the New York State Constitutional Convention of the Woman Suffrage Amendment Campaign Committee. Susan B. Anthony's signature is typed and followed by "Per I.R." It says:

My Dear Senator Palmer:

My friend Mrs. Israel Hall, of All [sic] *Arbor is arranging for a Woman Suffrage convention in that city on January 15, 16, 17—and desires me to invite you to speak at one of the evening sessions, you to choose your subject and speak from 30 to 40 minutes. Mrs. Hall is very anxious to have the best of speakers that a good impression may be made upon the 2,600 students and their professors. The Rev. Ann Shaw and myself are to be there and I do hope you will say that you will also. With the adverse decision of your Supreme Court, the women of Michigan are not a little*

*discouraged. The meeting is to be under the auspices of the State Equal
Suffrage Association and those women who have wrought so long and so
faithfully deserve your good presence and good word to cheer and help them
at this time. Hoping you will say yes, I am, gratefully yours.*

There is no indication that he gave a speech, even though the letter is
marked "answered Dec. 21, 1893." It still shows us his influence on this issue.

Palmer may have intended to attend the annual meeting of the
Association for Advancement of Suffrage in January and February 1889
in Lansing. However, he was due in Spain shortly and had to put his
affairs in America in order. He did send a draft of $100, which was a nice
sum of money in those days, and a note in which he stated strongly that
the "equal suffrage in municipal affairs means better statesmen, better
ordinances, better affairs, better administration, and lower taxes…a
better race." He encouraged the attendees of the meeting to "Agitate!
Agitate! Agitate!"

4

PALMER'S OTHER
POLITICAL POSITIONS

Palmer was rumored to have been offered the position of secretary of agriculture in Harrison's cabinet, but it did not work out. President Harrison, unsolicited, appointed Palmer as envoy extraordinaire and minister plenipotentiary in 1889. He presented his credentials to the Spanish government on June 17, 1889. In the spring of 1890, Palmer's niece, Mary (Molly) Roby Hamilton, and her husband, Colonel Hamilton, came to visit. Mary was Palmer's only heir. The couple stayed several days. The Palmers left Spain on April 19, 1890. During this return trip, they received word that Mary, weakened by a congenital heart disease, had died of pneumonia on April 29, 1890. The Palmers were heartbroken. Palmer had now lost his entire family. This undoubtedly contributed to his decision to retire from political life.

But Palmer was convinced to be president of the National Commission on the World's Columbian Exposition from 1890 to 1893. There was pressure on the senator to run for Michigan governor or president of the United States. He was also considered for a cabinet post, such as secretary of the navy or secretary of war. But Palmer refused all public office.

In 1888, the *Detroit Sunday News* reported:

> *There is a growing belief that Senator Palmer will yet be recognized. The President has had a quiet consultation with him and while the matter is yet uncertain, it is not improbable that he may ask Mr. Palmer to preside over the Department of Agriculture. Today's* Baltimore

Senator Thomas W. Palmer in the Court of the Lions at the Alhambra palace in Granada, Spain. Notice the columns in the rear of the photo. We will see them again on the façade of 300 Whitmore in the apartment district. *Courtesy of the Burton Historical Collection, Detroit Public Library.*

Sun *says: If Gen. Harrison permits himself to be influenced by the majority of the republican Senators, Senator Palmer of Michigan will certainly have a portfolio given him. There was an enthusiastic Palmer boom in the senate today and many leading republicans predicted that the Michigan will be invited to preside over either the agricultural or navy departments.*

Palmer also introduced and spoke in favor of a bill to restrict immigration. He prepared the first record for reference with statistics of immigration. His

memorable slogan "Equal rights for all, special privileges to none" is from a speech on the encroachment of the railroads, which he delivered in the Senate. Palmer spoke on a bill introduced in the Senate in April 1886 on the regulation of railroads.

To begin, Palmer said, "I expect to give my vote to this bill not because the scope is all that I could approve, but because I regard it as looking in the right direction and because I trust that its operation will educate and prepare [*sic*] for more comprehensive legislation."

He went on to cite the "beneficence of railroads. It had annihilated time. Its speed had made the transfer of a year's food from one coast to the reducing the price of a day's labor." He spoke highly of how manufacturing centers such as Detroit and St. Louis could receive supplies and ship out products faster.

He continued by pointing out the spread and growth of intelligence of ancient peoples once they built road systems. Modern commerce used these road systems as the spine of their growth. Palmer said, "Railways and steamboat routes are improved highways, not a new but a developed feature of the advancement of the race. The question at the front today in this country and in Europe is not how to cripple or restrict railroad building, or railroad operations is not how to do away with the vast commercial power…but how best to promote them that they may continue to serve rather than to rule the interests of individuals and communities."

Palmer felt America should emulate the Europeans, who had few restrictions on their railroads. Their systems were less complicated than the American system. Consequently, he argued, their systems were more efficient. He went on, "Under our somewhat complicated system of government the railroads were chartered by states, who bestowed upon them the right of eminent domain and they were builded wholly or in part by contributions directly from the state or by the people along their line and they were intended for the common and equal service of all who chose to make use of them."

Palmer closed his speech with five points he saw the bill addressing. They were: all charges are fair; unjust discrimination shall be a misdemeanor; facilities shall be furnished without unjust discrimination; charging more for a shorter than a longer distance shall be unjust discrimination; and lastly, rates and regulations shall be made public.

Near the end of the speech, Palmer said:

> *Railroads are beneficent servants but they must not become masters. The dwarf has grown large enough for us to impose restrictions upon his growth*

else the old fable will be illustrated in practical life. If unchecked he bids fair to develop into an Afrite [sic] of gigantic stature and overwhelming and malignant influence. Railroads are long dull, insensate things. They are imbued with intelligence and an intelligence that neither slumbers nor sleeps. They are no longer joint stock companies; they are dynasties…All the American citizen has asked in the past or will ask in the future is a fair chance; no odds of the government but its protection, for which his life is pledged and its schools for which his money is paid. Special privileges for none, equal rights for all.

This speech was interesting, since railroads were necessary to haul the iron ore and timber from Michigan's Upper Peninsula to market and enriched Palmer and his neighbors. Colonel Hecker and Charles Lang Freer, who founded the Michigan Central Railroad, both lived a block away from the Palmers.

From examination of correspondence at the Reuther Library, it is obvious there were many trying to get the senator involved in business schemes or who would like him to write a mortgage for some deal or make a loan. Many of these requests seemed to be concentrated during the time of the World's Columbian Exhibition in Chicago. The senator was the president of the committee operating the fair and was thus very visible. The senator mostly refused politely. A letter from J. McGregor, dated February 1893, is typical:

I want you to have the opportunity to be the new Republican Party nominee for President four years hence; consequently I want to prevent the old Republican Party from choosing another machine senator. I could have so directed the movement of the third party as to have done it in this election. I can do it two years hence, if allowed. I want you to be able to say two years hence "Gentlemen, I told you so, now go on to your own destruction or listen to me and bring order out of chaos."

On the third page of this letter, after praising the senator's influence, McGregor asked if the senator could loan him $20,000 for him to invest in a new stock company. There was a chance to buy a steam barge to deliver coal and other goods along the Great Lakes. McGregor says, "The lumber trade will be good for fifteen years to come. A boat built in 1891 rating A will last for ten years with only ordinary care before she would need much repair…I would expect to pay you back also any sums you and I could agree upon spending in the next two years in Michigan in political missionary work."

McGregor had attended the party convention and reluctantly accepted the nomination as lieutenant governor.

McGregor ended his letter with:

> *Several of us who were in the organized industrial movement saw the time two years ago last July to organize a movement in Michigan as well as other states of the Union that would finally annul the strike method among working men…You was* [sic] *by honest, intelligent farmers discussed at that convention held two years ago last July at Lansing…I believed you were honest when at the banquet of the Michigan Club you advised the republican leaders to "put their ears to the ground" and listen to the tread of the labor movement.*

John Brownell, writing in *Gems from the Quarry and Sparks from the Gavel,* a Masonic publication, said of the senator, "I have seen him prosecute the rights of the poor and homeless to their enforcement when rich corporations, capable of thwarting any ambitions he might have cherished, barred the way."

The senator showed his oratorical skills in "The Grand March of Progress," a speech given on December 21, 1891, at a dinner given by the New York members of the National Commission for the World's Columbian Exhibition at Delmonico's. Palmer was the unanimous choice for president of the exhibition's board. He said:

> *The character of our civilization is changing. The unsatisfied demand for more room must be satisfied by the creation of better room. Our people must seek adjustment under changed conditions. It is of much consequence to us all how we shall adapt ourselves thereto. Shall we rise to a higher or sink to a lower plane?…The pessimist sees anarchy and spoliation of the rich in the future. On the contrary, I believe that the right of private property will prevail just as long as the wealthy prove themselves worthy of its possession.*

Palmer's words here and elsewhere are strongly on the side of the small business people, the farmers, the average workers who felt the gap between them and the wealthy. Palmer's words have resonance in today's debate on the 1 percent. It is interesting that Palmer supported the rights of the poor and the small businessman but spoke broadly in favor of restrictions on immigration. In an address before the alumni of the University of Michigan on June 29, 1887, Palmer said:

In the confidential relations of life we demand of those coming to us certificates of character and I know of no reason why we should not demand the same from those coming to form a part of our great national family. Why should they not bring certificates of character, properly authenticated by our diplomatic or consular officers as to their value and validity, to be scrutinized by our national officers on their entry into the United States? We now have a quarantine system, to protect us against physical contagion. Why is it not our duty as well as our right to make a moral and political quarantine mandatory to the end that men entertaining convictions or vagaries as the case may be hostile to our theory of government, anarchical, nihilistic and destructive of our Institutions, should be excluded. We have still room for brain and brawn, but they must be directed by loyalty to order and good government.

While immigrants trying to enter America and found with some minor illnesses were quarantined, that was only until they recovered. The type of overall quarantine Palmer suggested had not been done. The idea of a "moral and political quarantine" would be unusual here. Nowhere in the address does he describe this kind of quarantine. Furthermore, his stance is at odds with the fact that he later adopted a foreign-born child. But that adoption was several years in the future.

In March 1893, some in Congress sought to denationalize the World's Exhibition. Some $570,000 was in jeopardy. Congress saw this amount as a loan to be repaid out of gate receipts. Palmer argued that it was covered by $2,500,000 coming from an appropriation to cover expenses of closing the exhibition on Sundays. "We are on the brink of losing everything in that line on the last night," Palmer said. He won the day, and the exhibition continued.

5

THE PALMERS AND THE
BUILDING OF THE
DETROIT MUSEUM OF ART

The Palmers were among the major benefactors of the Michigan Soldiers and Sailors Monument in Campus Martius in downtown Detroit. Many of Detroit's leaders of society were disappointed the city did not have an art museum. In 1883, the city leased a large lot adjacent to Saint Anne's Catholic Church on Larned. A twenty-six-room art museum was erected. It was open from September 1, 1883, to November 12, 1883. During that time, 134,924 persons visited. On April 5, 1883, Senator Palmer wrote to Mr. Brearley, the organizer of the exhibit:

> *Dear Sir—Believing that the City of Detroit has taste and wealth enough to fund and maintain an art gallery which will be creditable to the culture and public spirit of her citizens, and desiring to contribute thereto I have this day put into the hands of Hon. William A. Moore securities in the amount of $10,000 with interest from January 1, 1883, for the purpose of aiding in the purchase of a lot and the erection of an art gallery thereon.*
>
> *Said securities will be turned over by Mr. Moore for that purpose when $40,000 shall have been secured from other sources and a corporation shall have been formed, or some practical plan shall have been adopted to accomplish the end in view, provided said conditions shall be met by July 1, 1884.*

A restrained brick building was erected in 1883. It was replaced by a larger Richardsonian-style structure in 1888 designed by James Balfour. It was located on East Jefferson and Hastings near present-day Interstate 375. In the 1920s, Paul Cret designed the building we know today. This building was constructed on Woodward on the sites of the Ferry and Palmer homes. The senator was the museum's first president. Elizabeth Palmer was also on the board.

6

THE PALMER CHILDREN

As noted earlier, the Palmers had no natural children. Usually, we say the Palmers adopted three children. Harold (Higinio Costellar Poblacion, or Higinio Poblacion y Carpenter; born in Spain on January 11, 1882, and died in Massachusetts on March 25, 1983) was the only one we can really say was adopted. He was adopted while the Palmers were in Spain in 1890, when he was three years of age. Gail Palmer and Bertita Brown were older and were more wards of the Palmers. Bertita married C.S. Boothby in Vermont. They settled in La Grange, Illinois, and had one child. Bertita became Elizabeth Palmer's traveling companion, mostly during her month-long vacations in Havana. Gail married Zachariah Rice, a local architect. They had two children, a boy and a girl. Harold married Winifred Corbett (born in Detroit on October 30, 1884, and died in Massachusetts on November 22, 1973) and had two daughters. Harold and his family stayed in Detroit until 1937, when they moved to Massachusetts. We do not know how Gail and Bertita met the Palmers.

There is a story behind Harold's adoption, but we don't know if it is really true. The story is that one day, during Palmer's time as envoy, Elizabeth went to the beach. While there, she saw a small boy, about three years old, arguing with an older child, probably his sister or a babysitter. The boy did not want to swim, but the girl pulled him into the surf anyway. Elizabeth was charmed by the way the boy held his ground against the girl. Elizabeth introduced herself. The boy was Higinio Costellar Poblacion. His father was low-level army officer Pablo

Poblacion, and his mother was Eulaila. Higinio had a brother named Paco or Pablo (records are unclear) who stayed in Spain with their parents.

For a clearer picture, we turn to Emma Stark Hampton, reporting in the *Chicago Herald* of Wednesday, September 24, 1890. First, she sets the scene with the waves breaking on the beach, which was called San Sebastian and was on a little bay called La Concha (meaning the Shell). In the nearby hills, one could see the grandeur of the old Castillo de la Moat. The waves were rolling in, to everyone's pleasure. Hampton continues with a description of a little boy, Higinio Poblacion y Carpenter:

> *The young señor's little yellow eyebrows knitted like golden threads and his eyes snapped fire. His nurse was in despair. When she attempted to lead him down into the rolling waves he kicked his tiny feet into the air, and then fell down into a squirming, wriggling heap on the sands. And when the persistent nurse dragged him into the water his objections grew still stronger. As the water crept up around his waist and finally reached his stomach, for some reason his breath left him. Then he raised his arms above his head and gasped. And then he screamed…It was a wonderful scream and it made young Señor Poblacion his fortune.*

The Palmers were nearby, and Elizabeth wanted to go help the boy and his nurse. The senator dissuaded her from going to help because he knew that she, like the child, had a fear of the surf. However, the next day, the scene was repeated with the same cast. Hampton reports:

> *The next morning however, the screams were repeated and then in spite of remonstrance she (Mrs. Palmer) rushed to the beach and to the baby's rescue. Her maid, Francesca, a Mexican girl, ran with her and they in mingled English, French and Spanish accompanied by gesticulation called the woman and the child from the water…The girl promised to call upon her and did so with the pretty baby. Thereafter for six weeks the baby was a constant caller at the hotel…He was the son of Lt. Pablo Poblacion of the Infantry of Africa of the Spanish army and descended from the Goths, who invaded Spain about the year 400 A.D. He was of purest Castilian blood, never having contaminated it. His mother, Señora Bosillio, was one of the most beautiful women in all Spain. She was, unlike most Spanish women, a blonde with golden hair and eyes blue like the laughing boy.*

The rest of the summer passed, and the boy called at the hotel often. Elizabeth contacted the boy's parents, offering to adopt the child before they left in October.

> *Mr. Palmer invited the Lieutenant and his family to Madrid. They came and stayed at the ministerial residence until the lieutenant's six week furlough, which Minister Palmer had secured from the Secretary of War was up and then Palmer's [sic] adopted the child. The papers were drawn up in which Mr. and Mrs. Palmer agreed to bring up the child, educate it and in case of their death, to restore the child, with an annuity for its support and completion of its education. They also agreed to have the child instructed in Spanish.*

Just before the Palmers left Spain, to the ministerial residence came Spain's great orator, democrat and poet, Emilio Castelar Ripoll. Higinio came into the grand reception room of the residence. There, Castelar laid his hand on the child's head and "baptized" him Murillo Castelar Palmer. The significance of the name (which Harold seems to have never used again) is unclear. To have the fourth president of the First Spanish Republic (1873–74) lead the ceremony was an honor. We do not know how Castelar was connected to the Palmers or to Harold's family.

Harold kept in contact with his parents. The Palmers paid their costs when they came to visit. Hampton writes: "The story that money was paid for the child is a mistake. Little Murillo is bright, intelligent, affectionate and responsive. Murillo Castelar Higinio Poblacion y Carpentaro Palmer may be glad in after years for his nurse so cruelly plunging him in to cold Bay of Biscany that sunny morning." The rumors about paying for the child came about when it was learned that his father earned only the equivalent of thirty dollars a month.

A letter from Palmer to Don Pedro Poblacion and Madina de Campo, written in January 1893 from the exposition, illustrates the good feelings between the families:

> *Your kind note of the 7th inst. received today, having been forwarded to me by my wife in Detroit. She is well, as is also [sic] Higinio and Bertita. At the present time Bertita is a thousand miles away from us, or a day and a half's journey. We received your telegram on New Year's which I answered. There are some long intervals between letters, which gives my wife some anxiety. Higinio is growing and is a very fine boy, but my fears are that his*

Mamma is not training him in the way he should go; still, as he has a very good mind, I rely on that to bring him out all right in the end.

In regard to your coming to our country I will say that there is no immediate haste. Your passage across the ocean will be more pleasant in May then now, and by that time we hope to have your furlough all arranged, if you have difficulty in procuring it from the War department I hope they will give you one for three or six months. If you do succeed please inform us, and I will write to our Minister at Madrid asking for his intervention in the matter.

At the time of the above letter, Bertita was a student at the Gorham School in Gorham, Rhode Island. We do know that Harold's brother came to America frequently between 1908 and 1910. Harold was then studying at Cornell. The senator chided Harold for having more time to cruise around in his Packard Runabout with his brother than for studying. He encouraged the boys to study hard, and he paid tuition and travel expenses for the boys each time Paco came to visit. He recommended that Harold study law. Harold did and became an attorney, returning to Detroit, where he handled legal issues in the senator's office.

THE PALMERS RETIRE

Senator Palmer retired to Walnut Lane, a grand house on the Detroit farm. Elizabeth retired to their estate Oh So Cozy Little Farm in Great Neck, New York, which she had bought about 1905. They also had a home in Larchmont, New York. Sometime around 1900, the senator's widowed cousin, General Friend Palmer, came to live with him. Catherine Taylor, a Canadian, was their housekeeper. The general died around 1910. The senator died on June 30, 1913, at Walnut Lane. Two of his children, Harold and Gail Palmer Rice, were at his bedside. Elizabeth was at their home in Larchmont and too ill to attend the services. He was laid in state at Walnut Lane and buried in the family mausoleum in Elmwood Cemetery in Detroit. Dr. James B. Angell, president emeritus of the University of Michigan, delivered the eulogy. The senator's favorite hymns, "By Cool Siloam's Shady Hill" and "Nearer My God to Thee," were played.

Elizabeth died on July 28, 1916, and was buried next to the senator. Today, sadly, their mausoleum has been vandalized. Its stained-glass windows are gone, as are the bronze doors that stretched across the entry. The empty spaces of windows and doors are closed off with concrete blocks.

The senator's will appointed his son, Harold; George Brady; and Robert McClellan as executors of his estate. Brady and McClellan were longtime business associates. With Palmer, they had established the Log Cabin Farm Land Company, a land development company, to handle all Palmer's land plans. Harold wrote to his mother about the sad condition of the senator's affairs, which Harold had repeatedly asked the senator to allow him to

handle. For reasons unknown, the senator did not do this in his lifetime. Due to these issues, the senator's estate was not completed until early 1923. Elizabeth's estate was in good order, as she appointed Harold her executor, and he handled all her business affairs while she was alive. Although she urged Harold to take a fee for his services out of her estate, he refused to do so. He felt that this was a son's duty to his mother, and no payment was necessary. He signed his letters as "your dutiful son" and she as "your loving mother." He encouraged her to visit by saying how much his wife, Winifred, and their two daughters, Winifred and Marie, wanted to see her.

Harold's insistence on not taking a fee for his services to his mother clashes with local views of the pair. The local story is that Harold challenged Elizabeth's will because he did not receive anything from it. Supposedly, Elizabeth felt that the senator had provided for him amply by leaving Harold the acreage that is now the neighborhood of Palmer Woods. The truth, according to Palmer papers at the Reuther Library at Wayne State, was that Harold did not contest his mother's will. Examinations of letters between them from about 1914 to her death in 1916 indicate a warm relationship. She encouraged him to bring the family east to visit at one of the Palmer estates. There are telegrams from her giving instructions for a trip in about 1914. Harold was worried about her health and urged her to see a doctor. He complained that the Log Cabin Farm Land Company couldn't seem to sell the plot of land that was platted in 1912 as Log Cabin Farms No. 1. This land later became part of the public park and the Merrill-Palmer subdivision in 1923, which is now the apartment district.

The will was contested in probate court in Long Island by John Heger of Great Neck. A copy of the claim is stored at the Reuther Library. Heger claimed not only Oh So Cozy Little Farm but also $500,000 to be a maintenance fund and also fund "intimate personal services." These services are not explained.

Heger and Elizabeth had met in 1909 at a dinner given by Mr. and Mrs. Charles Whittier, distant cousins of Elizabeth's in Great Neck. Elizabeth complained that she didn't see her children enough. Harold was always away on business and Gail and Betita were busy with their families, leaving her without companionship. The Whittiers then presented a solution. They had a ward, John Heger, who had lived with them for seven years. They were having some monetary problems and suggested to Elizabeth that she take over care of the young man. His age is unclear. Both he and she were delighted at the new arrangement. Heger moved into Oh So Cozy Little Farm soon after.

Elizabeth expected Heger to perform the duties of a son. He was to entertain guests, ensure they had refreshments and cut the meat at dinner. He traveled extensively with Elizabeth, often checking into hotels as "John Palmer." All seemed to be going well. Elizabeth paid Heger's tuition at Westchester State Normal College in Westchester, Pennsylvania. Once there, Heger met a young woman, Florence Fisher, in 1911. They became engaged. According to the complaint, when Elizabeth heard of the arrangement, there was a serious argument between her and Heger. She threatened to stop paying his tuition and cut off his allowance. He eventually broke the engagement. She ordered him out of the house, as evidently had happened before, but again, he got back into the house.

The complaint goes on to say that several times, Elizabeth had remarked, "Johnnie gets everything," in front of visitors and the staff. One day, she supposedly called him into the sitting room. She was holding some papers she claimed were her new will, which left the farm to him, along with several thousand dollars to maintain it. There were several incidences like this over the next months. The only will I could find was dated May 1916 and does not contain any mention of John Heger. As of this writing, there is no further information on Heger. There is no information on whether he married Fisher. There is an indication that he might have started over with the relationship after Elizabeth's death.

The complaint details instances where Heger and Elizabeth argued quite fiercely, with reconciliations quickly following. She complained that he didn't entertain the guests properly. The bulk of the letters seem to be about small things, such as the preceding example and that sometimes he got childish. The letters attached to the complaint are undated and don't make Heger look good. He showed no proof to back his claim. There are no rebuttals or any indication the rest of the family knew about Heger in the sources I have been able to access as of this writing. There is a note, dated 1918 (two years after Elizabeth's death), in which Harold Palmer approves Heger's petition to have some pieces of her jewelry and unspecified personal effects.

The Palmers and the Establishment of the Merrill-Palmer Institute

Elizabeth Palmer's estate was estimated to be worth $5 million, with a substantial portion (including the land that is now the apartment district) left to the Detroit Women's Club and designated for the establishment of the Merrill-Palmer Institute for Motherhood and Home Training, which is now known as the Merrill Palmer Skillman Institute at Wayne State University. She was as passionate on the issue of motherhood and family strengthening as the senator was about suffrage for women. Throughout its history, the institute has participated in testing and establishing a variety of programs aimed at maternal and child development. It is now located in the Charles Lang Freer home on Ferry Street in Detroit. Freer created the Freer Gallery of Art in Washington, D.C. The museum houses the famous Peacock Room, built to display Freer's porcelain collection. The walls were adorned with paintings of peacocks done by renowned artist James McNeill Whistler. Harold Palmer, George Brady and Robert McClelland were members of the original board of directors for the institute and served for many years.

The ninth clause of Elizabeth's will, dated May 17, 1916, stated her philosophy and vision for the institute:

> *I hold profoundly the conviction that the welfare of any community is divinely and hence inseparably dependent on the quality of its motherhood and the spirit and character of its homes and moved by this conviction I hereby give, devise and bequeath all the rest, residue and remainder of my*

estate of whatsoever kind and character…for the founding, endorsement and maintenance in the City of Detroit or the Township of Greenfield…a school to be known as the Merrill-Palmer Motherhood and Home Training School…for girls age 10 years and women shall be educated, trained developed and disciplined with special reference to fitting them mentally, morally, physically and religiously for the discharge of the functions and service of wifehood and motherhood and the management, supervision, direction and installation of homes.

9

THE ESTABLISHMENT OF PALMER PARK

With the completion of Walnut Lane, the Palmers donated the first 120 acres of their farm to be used as a public park. This excluded the cabin and Lake Frances, which were donated in 1897. The senator called it Log Cabin Park, but the city insisted it be named Palmer Park. The *Detroit Free Press* of August 22, 1897, said, "The idea of changing the name of Palmer Park to Log Cabin Park is not acceptable to a great many people that take an interest in matters pertaining to the municipal welfare. Mayor Maybury for one offers strenuous objection to any such change."

The only stipulation was that the city could not cut down Witherell's Woods, which occupy most of the gift area. The following song (sung to the tune of "My Michigan") was composed by mayor's secretary Joseph Greusel McLeod and Colonel Farnsworth in honor of the senator and his gift:

Tom Palmer's Park! Tom Palmer's Park! We take it from him thankfully, We'll care for it, and treasure it so cheerfully, twill be the gem of our fair town, and keep forever bright our crown Tom Palmer's Park!

Tom Palmer's Park. Home of my heart I sing of thee, Log Cabin Farm, Log Cabin Farm! Thy woods and glens I long to see, Log Cabin Farm, Log Cabin Farm, from Witherell woods to Merrill dale, from lake to meadow, field and dale, thy sylvan beauties never pale, Log Cabin Farm, Log Cabin Farm!

Home of my heart I sing of thee—Log Cabin Farm, Log Cabin Farm! Thy woods and glens I long to see, Lob Cabin Farm, Long Cabin Farm

A History of Detroit's Palmer Park

from Witherell Woods to Merrill vale, From lake to meadow, field and dale, thy sylvan beauties never pale—Log Cabin Farm, Log Cabin Farm!

The city boasted that Palmer Park had seventy kinds of trees. There were seven kinds of oak, eleven of willow, five of thorn and others such as elm, maple, balm of gilead, slippery elm, plum and cherry. In addition to the trees, the park had forty kinds of shrubs and plants, including flowering dogwood hazelnut, wintergreen, huckleberry, raspberry, blackberry, honeysuckle, poison ivy, gooseberry, currant and rose. There was a nursery on the north end of the park used for starting various ornamental trees, shrubs and plants. There were hothouses about one thousand feet east of the casino, where thousands of flowers were readied for transplanting into the park's many flowerbeds. Postcards of this part of the park show long rows of hothouses and generous flowerbeds.

Contemporary accounts compare Palmer Park with Belle Isle (the island park on Detroit's east side), saying, "No one who has visited Palmer Park can fail to remember its wild beauty, its delightful footpaths and roadways the little log cabin full of old fashioned furnishings and valuable relics, the pretty lakes, peopled with ducks and swans, the miniature lighthouse in the center of Lake Frances, the flowers and the trees."

Thousands visited the park in the years after its donation. The majority of the visitors are said to have been women, young people, children and, often, whole families (especially on Sundays). There were church picnics, Sunday school picnics, teachers and their classes and various benevolent and social organizations. The claim has been made that as many as fifteen thousand persons came to the park on a typical Sunday.

THE LOG CABIN

There is a story about the origin of the log cabin that is the centerpiece of Palmer Park. This story of its construction has generally been believed to be false. Recent scholarship revealed that the story is true and was told by Senator Palmer in a December 4, 1904 *Detroit News* article:

> *Mrs. Palmer used to have a great fancy for piling up brush and setting it afire. While I was aiding her in this amusement one day we stirred up a hornet's nest and made a neck-and-neck race to the knoll on which the cabin stands. When she recovered breath her first suggestion was that she would like a log house. She had had stone houses, brick houses and frame houses, but never a log house. Of course she got it and later it was she who built the lake and the miniature light house* [sic] *and rustic bridges. The furnishings of the cabin are from our respective families, a number of the articles having come to Detroit in 1808.*

More recent scholarship has uncovered an expanded version of the story. It is contained in a February 14, 1910 letter from Palmer to Helen Wetsell of Belleville, New Jersey. "In re [*sic*] the log house which has become celebrated. I will give you a brief outline of its history. It is very unlike the primitive log houses of other days, being equipped with all modern improvements such as toilet rooms, a number of bed rooms, good fireplaces…The origin is this… [he continued with the familiar story of the nest of yellow jackets]."

The story continues:

She completed it [the log cabin] *and then said that she needed a lake, so we had a lake dug; then she wanted fish in the lake and I being on the committee on fish and fisheries I procured a lot of carp which we put into the lake which has been filled with seepage from the sand knoll by the rain fall. Trees were set out around it and flourished. Then she found that the carp muddied the water so that we had to dispose of them. We drained and pumped the water out and let the banks lay for six months to kill the spawn then let the lake fill up again. At that time we had no water from the City, but had to fill it by pumping with windmill and engine.*

The cabin was built of local lumber by a local worker on the knoll Mrs. Palmer had indicated, which was also called Font Hill. The builder was Anthony Flewelling, who had built many structures in the area and in Detroit. His top workman was Joseph Ray, whose descendant still lives within a mile of the cabin. The *Detroit News* of January 28, 1923, tells us Ray served in the navy during the Civil War and, for a long time, was stationed at Hampton Roads. Upon his return to Detroit, he engaged in the carpentry business.

Palmer goes on to describe some of the furnishings, such as portraits of grandfather and grandmother Witherell and of his uncle Bonepart, who died in Hampton Roads after chasing pirates in 1818. Noting that the cabin sat in a park that is composed of acreage Judge Witherell bought in 1823, he writes that the territory between the cabin and Detroit is boggy and

they paved the avenue which is the principal avenue of the City [I take this to be Woodward Avenue, the eastern side of the park] *out to the farm. Logs of which were parts of the corduroy were dug out from beneath the surface which measured some of them two feet in diameter… The house in which I live* [Walnut Lane] *is on the farm and an electric railway gives access to it. The park is lighted by electricity and they and we have all the conveniences of the City. The golf grounds of over a hundred acres lie adjacent to the park.*

The confusing aspect of this letter is that Woodward Avenue was paved, and logs from the old corduroy road were found. But this was in 1912 and is the first mile of paved road in America. The senator died in 1913, so he would have seen the paving work in his lifetime but not two years prior.

The senator contracted with architects George Mason and Zachariah Rice. Mason (1856–1948) was born in Syracuse, New York, and came to Detroit in 1870. He started his career with architect Hugh Smith in 1875.

He moved to the firm of Henry T. Brush. Rice was born on September 9, 1855, in Oswego, New York, and died in Ypsilanti, Michigan, in 1929. The family moved to Detroit in 1861. He graduated from Detroit High School in 1872 and entered the office of Brush and Smith.

About the time they were contracted for the cabin work, Mason and Rice hired an apprentice named Albert Kahn. Kahn grew to be internationally recognized for his commercial work for Henry Ford and his many lavish homes for wealthy Detroit industrialists. Mason and Rice (in partnership from 1878 to 1898) designed the Grand Hotel on Mackinac Island and the original Hotel Pontchartrain in downtown Detroit. On his own, Mason designed the Masonic Temple on the edge of downtown Detroit, which opened in 1928. It is considered to be the largest Masonic Temple in the world with some one thousand rooms. Mason was called the dean of Michigan architects. He died in 1948 at age ninety-two. Rice married Gail Palmer (the third of the Palmers' adopted children).

The cabin consists of a central hall flanked by four rooms downstairs and four upstairs bedrooms. There is also an indoor privy on the first floor. The second floor has four bedrooms. The kitchen is a lean-to in the rear of the cabin. There are two fireplaces on the first floor. The cabin was built with logs cut from the surrounding forest. The senator filled the cabin with family antiques. This included the cradle that held the senator as a baby, Judge Witherell's grandfather clock and a canoe hanging from the dining room ceiling. There was Judge Witherell's mahogany-cased clock, about seven feet tall and moved from Vermont by Senator Palmer in 1876. A verse written by an unknown poet was attached to the clock: "I am old and worn as my face appears, for I've walked on time for a hundred years; many have fallen since I began; many will fall ere my course is run; I've buried the world with its joys and fears; in my long, long march of one hundred years."

Friend Palmer found a clipping about the cabin in the September 9, 1888 issue of the *New York Sun*. It describes the antiques and then talks about the woodlands. The paper said, "One feature of the place is a series of avenues cut irregularly through the beautiful groves surrounding the house. No attempt is made to artificially improve the beauty of the grove. Walks are cut through, the underbrush cleared away and nature depended on to do the rest."

Today, Manderson Avenue remains as the western border of the National Historic District. For many years after the 1890s donation of the cabin to the city, it was used as a museum.

The log cabin's interior, looking from the senator's parlor to the central hall. Date unknown. *Courtesy of the Burton Historical Collection, Detroit Public Library.*

William Christian, secretary of the parks and boulevard commission, wrote to Palmer in December 1895: "Your tender of the Log Cabin to the Commissioners under date of December 14th authorizing them to take possession of the premises and assume the care and custody of the building on condition that you can occupy it and the stable adjoining when you felt so disposed, was accepted and the thanks of the Board are herewith conveyed for this most substantial and acceptable gift."

During Palmer's lifetime, the cabin became a focal point for picnics and large gatherings of all kinds. As historic architecture tours are conducted, the cabin is the one place that everyone remembers fondly. They remember the museum in the cabin, feeding the ducks and ice skating on Lake Frances in the winter.

11

LANDSCAPE PLANS FOR THE ESTATE

Elizabeth Palmer worked with estate manager Eber Cottrell and the firm of landscape architect Frederick Law Olmsted on the plantings around the cabin and throughout the estate. They planted verdant grasses, bushes, stones and various flowering plants. Eventually, a greenhouse was built. Souvenir postcards of the 1890s and early 1900s show several large greenhouses and substantial gardens. At one point in its history, Palmer Park greenhouses grew all the shrubs used in public places around Detroit. There was a windmill and several cattle and feed barns, as well as a "modern" creamery. The senator traded in both Percherons and cattle. For a while in the 1890s, the farm was called the Log Cabin Stock Farm.

We get an idea of what Olmsted proposed for a section of the park in an October 25, 1895 letter from Olmsted, Olmsted & Elliott to Senator Palmer:

We send you today under separate cover a sketch representing possible lines of development for the Merrill Plaisance. South of the cross road you will notice that we suggest that the central part of the public domain should be preserved as an open meadow, while its borders might be dotted with trees and framed by clustered shrubbery. North of the cross road the sketch suggests that the central part of the public land should be excavated to form a lake of irregular outline…between this lake and the boundary roads there will be lawns, trees and more shrubbery. At the north end of the lake the sketch suggests the creation of a music court…adjacent to this court, and at the water's edge, a site might be given to a public boathouse, the roof of

which with possible accompanying flag staffs would form the termination of the long vista which extends throughout the Merrill Plaisance from the end of Hamilton Avenue northward.

Unfortunately, the plans were not implemented. Most of this area is now the front nine of the City Golf Course.

PICNICS AT THE FARM

Everyone who visited the Palmers while they lived in Palmer Park was treated to a picnic on the farm. Visitors usually went by streetcar to Highland Park. They then boarded hay wagons to finish the remaining trip to the farm. The contents were removed in 1979 and are stored in southwest Detroit. A newspaper account from July 12, 1897, notes that several of Palmer's fellow senators visited, and each planted an elm tree with his name on a tag. One of them, Senator Manderson of Nebraska, has a street named for him in the apartment district. These trees were at the entrance to the park, which is thought to be where Covington and Merrill Plaisance meet Woodward Avenue today. The senator envisioned a shady promenade when they were fully developed. A formal grand entrance was planned to grace this section when the park was completed.

Even important foreign visitors were treated to a visit to Palmer Park. This included Swami Vivekananda, recognized worldwide as a peacekeeper and lecturer on Vedanta Buddhism. He spoke at the World's Conference on Religion at the World's Columbian Exposition in 1893. The swami came to Detroit in February 1894 and presented a number of lectures at the First Congregational Unitarian Church at Woodward and Edmund Place. The senator wrote to the swami, inviting him to be a guest at Walnut Lane. The swami came to Walnut Lane on March 11, 1894, after staying with the Bagley and Hale families. He stayed one night and then left Detroit to continue his lecture series.

The October 16, 1887 *Detroit Tribune* reported on a party the Palmers hosted for hundreds of residents of Greenfield Township (where the farm

was located), Detroit and elsewhere. Elizabeth asked her friends to cut bread for sandwiches. They eventually cut five hundred loaves by hand, plus made dozens of cakes marked with Elizabeth's initials. The Palmers stood for hours at the cabin door greeting their hundreds of guests, all introduced by Mrs. Langeley, the Greenfield poetess. If Elizabeth was "delicate and frail," as had been reported, this reception line must have been agony for her. The article notes that a dance hall was set up on the second floor of one of the barns. The report says that dancing went on until at least 1:00 a.m.

The *Detroit Tribune* continues:

> *A massive bonfire in the evening outlined gaily bedecked boats on the little lake, crowded with singing, laughing and shouting guests. Rows of Chinese lanterns circled the borders of the lake and the rustic bridges and American flags were seen fluttering in the breeze. Spiel's orchestra was off in the woods on the dancing platform provided for the guests who enjoyed an old country dance. Later in the evening, Senator Palmer expressed his deep feeling of enjoyment when he said, with pathos in his voice, "Dear old farm! I have at last reached one unalterable conclusion. It is out here—among these peaceful shades—that the closing years of my life will be spent."*

A September 2, 1900 newspaper article details a picnic for the brothers of Palestine Lodge of the Free and Accepted Masons. It was a corn roast. They had 150 dozen ears of corn, twelve bushels of roasted potatoes, ninety pounds of Palmer Park dairy butter, sixty gallons of ice cream, a wagonload of watermelons and a dry goods box full of cakes. There were said to be one thousand people in attendance. A table several feet wide and several hundred feet long was not sufficient to accommodate all who wanted to eat. Each of the brothers took up a different station (cook, chief dishwasher, etc.). This is the first time I have ever seen mention that paper plates were used at any gathering in this time.

At first, it surprised me that hundreds of people would attend these parties. It was difficult to get to the farm, requiring a trip by streetcar for part of the journey and then horse and wagon. The roads were either pounded earth or made up of logs from the surrounding forest. Then, I realized that entertainments and parties were few out there in the country, and people were willing to take the travel risks and the time to celebrate with their neighbors.

In the September 24, 1887 *Free Press* is an article describing a visit from the board of trade. There was a dinner, and then the piano was brought out.

One of the guests played while the group sang "Old Oaken Bucket" and "I'm the Son of a Gambolier."

They toured the farm. First, they saw the herd of fifty or sixty Percherons. Then, they saw the swine, the cattle sheds and the method used to supply water to the buildings. The barn was next, with its stalls and Jersey cattle. The barn had a steam engine that operated the elevator used for moving machinery and tools from one level to another, and it ran the grinding and other work. Then, they passed through the orchards. They ended at the stoop of the main house, where they drank cider before leaving.

THE MERRILL FOUNTAIN

In 1901, Elizabeth Palmer donated $1 million to build a fountain in memory of her father, Charles Merrill. It was placed downtown in front of the original opera house on Campus Martius. The designers were Carrère and Hastings of New York. The firm had designed the Standard Oil Building in New York, the New York Public Library and the Frick Mansion (now Frick Museum) in New York. Zachariah Rice supervised the firm. On the following page can be seen one of the few photographs known to show the fountain operating in its original location in downtown Detroit.

At the dedication ceremony, Senator Palmer said he was provided "an opportunity to launch into a dissertation on the historic fountains of Europe." He went on to say, "As men were crowded into great cities and denied the frequent sight of the contact with water in agitation or repose, a craving for it, as a feature of the landscape, has led to construction of artificial lakes, cascades and fountains to cool the air, please the eye and soothe the ear, as well as supply the physical wants of the people."

The fountain was moved to Palmer Park in 1925 because the city felt traffic on Woodward Avenue would damage it. The fountain operated for approximately one year after it was moved.

The fountain uses a classical architectural vocabulary. There is the keystone symbolizing strength. The Roman fasci, or bundle of reeds, symbolize the unity and the authority of the Roman consul. The fasci frame the tortoise, which is at the center of a large seashell framed by sea creatures. Ears of corn were placed between the ribs of the seashell and symbolize plenty. A

An undated postcard image showing the Merrill Fountain in its original location in front of the Detroit Opera House in Campus Martius. *From the collection of Allan Machielse.*

A detail of the Merrill Fountain. *Photo by Allan Machielse.*

marble balustrade stretches across the back of the pool. In the lower basin, there were three small turtles that shot upward jets. On each end of the balustrade, there were basins with rings to tie off horses. The fountain is currently in disrepair. One of the basins is missing. There is a large basin at the rear of the fountain. The keystone and bound fasci are repeated in the rear section. The tortoise has lost its head, a section of the balustrade is missing and the small turtles are gone.

THE SPANISH BELL

The bronze bell that hangs behind the cabin was found in a scrap iron shipment sent to the Keeler Iron and Brass Works about 1895. It was given to the senator, who placed it where it still hangs, about one hundred feet west of the log cabin. An inscription inside the rim reads, "Paula Gomez made this 1793." The legend sprang up that it once hung in the La Rabida monastery where Columbus stayed on his way to meet with King Ferdinand in 1492. It was rung occasionally to call picnickers to meals.

The Spanish Bell, shown in an undated postcard view. *From the collection of Gregory C. Piazza.*

The Mansion at Woodward Avenue and Farnsworth Street

In 1864, the Palmers built a large white clapboard home at the northeast corner of Woodward Avenue and Farnsworth Street in what is now the cultural center. W. Hawkins Ferry, in his monumental work *The Buildings of Detroit*, notes that the home is in the Italian Villa style, although its builders were given free hand to create this home. Contemporary sources note that the large house was filled with the senator's art collection, with pieces after Murillo and Randolph Roger's marble *Nydia, the Blind Girl of Pompeii.* The upholstered furniture had huge crocheted antimacassars.

There was a life-sized portrait of the senator painted by Eastman Johnson hanging in the hall of the house. Johnson also painted two smaller bust-sized portraits of the Palmers. The pictures are in the collection of the Detroit Historical Museum. The larger one is damaged, having three long scratches across it. Two of the scratches frame Palmer's head, and one is along the entire picture at Palmer's stomach. This probably gave rise to the fanciful story of Elizabeth carrying the senator's picture (à la Dolley Madison and Washington's portrait in 1812) out of the burning house. After the fire, the art museum asked the senator if it could display the portrait while a new house was being built. Across the letter, in Palmer's hand, is a note, "Sick. Deal with tomorrow." There is no record of any display of the portrait. Johnson was a co-founder of the Metropolitan Museum of Art in New York, and his name is inscribed over the entrance. He was well known for his genre paintings and portraits of Lincoln, Longfellow, Emerson and Nathaniel Hawthorne.

Above: Senator Palmer's residence at Woodward and Farnsworth. Date unknown. *Courtesy of the Burton Historical Collection, Detroit Public Library.*

Left: An undated interior photograph of Senator Palmer's residence on Woodward Avenue near Farnsworth. *Courtesy of the Burton Historical Collection, Detroit Public Library.*

In a March 5, 1909 letter to Fred Farnsworth, secretary of the American Bankers Association in New York, Palmer wrote, "I enclose you a letter of Mrs. Eastman Johnson which speaks of ahead and bust portrait which was painted at the time he painted my portrait which belongs to Mrs. Palmer and which is hanging up in the house here. I wish you would call and see if it is worth buying. Being Eastman it has an intrinsic value beyond that of mere likeness. She says I can have at my own price. I do not want to pay very much for it." The Detroit Historic Museum now has two bust portraits of the Palmers; they can be seen on page 16 of this book. The Burton Historical Collection of the Detroit Public Library also has bust portraits by Johnson.

The rambling house had a tall tower, built as the senator's office, and spacious rooms. Pictures of the interior from the late 1870s show typically overstuffed, deeply carved furniture of the High Victorian Gothic style. The Palmers came to this section of Detroit because of Elizabeth's ill health; this area was considered suburban and healthful. Today, it is the home to the cultural center of Detroit, which consists of the Detroit Institute of the Arts, the campus of Wayne State University, the main building of the Detroit Public Library system, the Detroit Historical Museum, the International Society, the Charles Wright Black History Museum, the College for Creative Studies, the Scarab Club for artists and patrons of the arts, the Detroit Science Center and the Rackham Educational building.

In early 1893, there were two fires that damaged the house. The first fire was small. The papers of the time reported that the senator and a couple of friends sat drinking tea in the parlor while the firefighters worked. The second fire was in November 1893 and was larger, severely damaging the house. No one was home at the time of the fire. Mason and Rice salvaged trim and other work for the new house described below. The Woodward/Farnsworth site is now the south wing of the Detroit Institute of the Arts.

The *Detroit Sunday News-Tribune* of May 31, 1896, printed the report of Emma Stark Hampton, a reporter for the paper, which described the demolition of the Woodward/Farnsworth mansion. The piece has a huge headline "Dismantled!!" In the beginning of the article, Hampton bemoans the destruction:

> *And so one by one, will the old landmarks, long familiar to Detroiters. This day and generation is gradually removing what our fathers and grandfathers builded* [sic] *with pride, for the steady march of progress demands more*

breadth, more height and greatly increasing facilities…Prominent over all in the dissolving views of the panorama of today is the beautiful home of Hon. Thomas W. Palmer, for many years a notable attraction on Woodward Avenue.

This article is the source for the fire stories told previously. Hampton encourages Colonel Fred Farnsworth to remember his childhood next door and the beautiful gardens at the Palmer estate. She details the damage, noting that the $5,000 portrait of the senator painted by Eastman Johnson was irreparably injured. Hampton reminds the reader that the interior was remodeled and finished throughout in French burl walnut. The work was designed and executed by Hersey & Company of Buffalo at a cost of $25,000. The first part of the article bemoaning the loss of historical buildings and landmarks in the city could be written today. There is a new spotlight on historic preservation in Detroit given the site chosen for the new hockey stadium, new housing and historic office buildings being converted to high-price housing, and now the Illitch family has announced preliminary plans for forty acres of land at the north end of downtown Detroit. This includes at least four historic buildings: the Park Avenue Hotel (to be demolished), the Hotel Eddystone (to be renovated), the Masonic Temple (to remain open for shows and lodge meetings) and the former S.S. Kresge world headquarters (to be used for offices).

WALNUT LANE MANSION
IN THE PARK

Mason and Rice designed a comfortable brick home called Walnut Lane in what is now the apartment district in 1893. Today, the site is the Unity Institute of Holistic Living (built in 1937 as the Fifth Church Christ Scientist) at Whitmore and Second. When the house was demolished is unclear, but recent research indicates it might have been late 1925 or early 1926.

The *Sunday News-Tribune* of August 29, 1897, reported the three-story house to be of steel frame with poured concrete floors covered with oak floors. The exterior was brick with granite trim. The walls were block with the veneer of brick outside, and the lathe and plaster, asbestos, marble and tile inside made for a very sturdy building. The house was reported to be thirty-two by forty feet or sixty by forty feet, with a large kitchen, the refrigerator room of which was eight by ten feet. The refrigerator was white tiled inside and out and had a large, padded door. The house faced east toward Woodward Avenue with a broad meadow separating them. It sat on a small knoll with an orchard behind it. The main bathroom featured a tub of white porcelain, of Roman style and make. It was imported at a cost of $300. The senator's study was positioned so that he could see people, especially children, enjoying the park. There are no known pictures of the interior of the house.

The article notes the home had a cornerstone made from stone salvaged from the destruction of the first Michigan Capitol, in what is now Capitol Park in downtown Detroit, as well as contemporary newspapers and coins. Once the house was demolished, this stone was lost. The article also notes

Walnut Lane shortly after construction. *Courtesy of the Walter P. Reuther Library, Wayne State University.*

the senator had a bowling alley in the basement of the house where he could go "at night after the 'harrowing' of the day is done." There was also a dry room where he stored a lot of his books and congressional reports until they could be catalogued.

Lake Frances

There is a small lake at the foot of the cabin knoll with three islands. The largest island has a white lighthouse. The body of water is named Lake Frances for Elizabeth's mother, Frances Merrill. There is some indication that there was a small stream that ran through this area fed by one of the nearby artesian wells. There is photographic evidence from the Library of Congress that shows the small stream that eventually becomes Lake Frances. A watercourse known as Stebbins Ditch crossed the Palmer farm from east to west and then turned southward. This course would put it around Lake Harold. There was a fish-breeding pond about where the water park is

Lake Frances, the rustic bridge and the log cabin. Date unknown. *Courtesy of the Burton Historical Collection, Detroit Public Library.*

today. Originally, there was a rustic log bridge at the north end of the pond, which has been removed and replaced with a concrete walkway. There was a warming pavilion/concession stand on the south shore of the island that is no longer in existence. The lake is now home to a large population of geese, many ducks and a heron. The lake has often been used as a meeting place and the centerpiece of the art fairs conducted in the 1970s and '80s, as well as more recent architectural tours and art fairs.

Palmer Park chronicler Crockett McElroy, in his 1908 *Souvenir and Illustrated History of Palmer Park*, tells us:

> *In the words of Senator Palmer "the lake is a perfect breeding pond for goldfish." Many thousands of these aquatic beauties have their home in the lake and they multiply rapidly, living there the year round; not only this, but they grow to an unusual size approaching two pounds in eight. Sometimes swarms of them give the surface of the water a reddish cast like clouds, reddened by a setting sun. The overseer states that he placed 66 goldfish in the lake eight years ago, that he has since taken out 50,000 and there are thousands left.*

It was said that the waters of Lake Frances turned gold when the fish swarmed. Older tenants told me that all of the fish had disappeared by the 1960s.

McElroy tells us that when Palmer was in Spain, he purchased an old plow and was told it had once belonged to the monastery of La Rabida, famous for the fact that Columbus stayed there while on his journey to see King Ferdinand and Queen Isabella. This is the same monastery that claimed the bell described in Chapter 14. Palmer donated it to the city, and it was displayed on the senator's farm.

LAKE HAROLD AND
THE PAVILION

In the west end of the park, there was a pile of stones with a waterfall called Pontiac Cataract (more commonly known as the Cascade). It was given this name because many believed that it is where Chief Pontiac met with General Anthony "Mad Anthony" Wayne during the Revolutionary War. Buttons and small items have been found in this area, but the story cannot be verified. People loved to climb the cataract since the water was shallow and slow moving. The two-acre lake at the foot of the cataract was named Lake Harold (or Higinio), for the Palmers' adopted son. It was connected to a very extensive water system designed specifically for the park. A July 1897 article in the *Evenings News Tribune* goes on at length about the six-inch water pipes that had been laid and connected Lake Harold to the city's system instead of depending on the farm's windmill. Most of the water to the farm buildings was supplied by a windmill.

The article goes on to say:

> *There will be a water pressure of 60 to 70 pounds in the pipes and to guard against the splendid forest, the log cabin or any of the buildings catching fire during the extremely hot weather, several fire hydrants will be put in and sufficient hose kept ready to fight fire. With only the ordinary pressure an inch stream can be thrown 100 feet. The length of the newly laid water pipe is about 5,000 feet. The little fountain in front of the water tower under the new water pressure has become a regular little geyser, shooting a straight stream of water into the air about 25 feet.*

The Cascade, shown in a postcard postmarked 1912. *From the collection of Allan Machielse.*

Lake Francis and its pavilion as shown in a mid-1910s postcard image. *From the collection of Allan Machielse.*

An island of about three-quarters of an acre named Inselruhe sat in the center of Lake Harold. The island was approached by two rustic bridges. It was filled in with earth excavated from the building of the

John C. Lodge Expressway in 1953. In 1896, Rogers and MacFarlane, a noted architectural firm, designed a large wooden casino on the north shore of Lake Harold. It was used for community events and dances. It burned down in May 1945, supposedly because there were no nearby fire hydrants.

THE SPRUCE LOG

The Spruce Log was the most unusual and popular of the attractions in the park. One end of the log was hollowed out and used as a lion cage. The other end was hollowed out into a room with seats and a table. It was thought the log was exhibited at the St. Louis World's Fair of 1904, but the Missouri Historical Society cannot find any record of it at the fair. Scholarship from the Chicago Historical Society shows the log was part of the Washington State exhibit at the 1893 World's Columbian Exhibition.

The Spruce Log, as shown in an undated postcard view. *From the collection of Gregory C. Piazza.*

The society does not have any record of who might have bought the log. A recently discovered *Detroit Free Press* article from May 23, 1905, advertising the sale of the log notes it had been exhibited somewhere along Gratiot Avenue in Detroit, but the article does not identify the seller. This may have been when the log came to Palmer Park. Another source says the City of Detroit bought the log at the Columbian Exposition and gave it to Palmer.

The Palmer Park Apartments National Historic District

In 1912, the senator and several longtime business associates filed a subdivision plat for Log Cabin Farms No. 1. For the south end of the subdivision (where the apartments are today), they envisioned a small town with curving, narrow lanes; limited traffic; and Walnut Lane as its centerpiece. There would be a grand entry for the public park located at Woodward and Six Mile. It would lead to a grand park and a golf course. A long street lined with large lots for upper-class homes went north along Woodward Avenue at the east end of the development, and another street would go west off Woodward for about a mile, where Seven Mile Road is today. When the senator died, the plan was abandoned.

The senator had a serious auto accident at the farm. As with the cabin, there are two stories about the senator's auto accident. One says that in 1912, the senator and business associate George Brady were being driven around the proposed development area. The senator's longtime driver was in control. They were likely using the senator's Olds Motor Company limousine and touring car. He had just started to U-turn at Seven Mile to go south on Woodward. The tires of the car got stuck in the tracks for the interurban train. Although the train was moving slowly, it hit the car. Brady and the driver stayed in the car and were unhurt. Palmer was thrown from the car and sustained several cuts to his scalp. He refused to send for a doctor. He was more concerned that his favorite cigars in his breast pocket may have been damaged.

In an August 1910 letter to G.A. Whittier of Brooklyn, New York, there is a slightly different version. Palmer writes:

Yes, I had an automobile accident. Drove right on to the middle of the track, stopped there and saw an electric car suburban coming right at me. I had about two seconds to think of eternity and then went flying into the air. If it had struck us eight inches ahead of where it did I would have been an angel. I went into the air and came to a stop on my head. If I had hit on my side I would have had my skull crushed but was hit on the apex of my dome and think the strength of my arch resisted the fracture. They say I bled about two quarts which has made me somewhat thinner. Save my insomnia which is aggravated I cannot see any bad effects at present except that I am duller in my so called mind. This is the second auto accident which I have had. One four years ago and one now and I live in hope that will not have another. I do not think I will have one road side one because hereafter when I cross a track I will be pretty sure there is no car coming either way. What the secondary effect will be I cannot tell, but will let you know from time to time. I do not see how you could miss the accident if you read the papers. It was in the papers of London, Chicago, New York and Royal Oak.

Recently, a search of the Burton Historical Collection revealed yet another version. This is found in a letter, also from August 1910, to Serena Kellogg of Fremont, Ohio. The basic structure is the same. Palmer was out with his driver and George Brady, his business partner. When they saw the train, Palmer and Brady jumped up just before being hit. Palmer said the rear end of the car was demolished. He was thrown out headfirst and sustained an injury to his head, "ripping the skull for six inches, so that you could put your hand in. This wound is healing well."

The injury was more serious than he had imagined. He now had problems and lost his bearings. He said that after the accident, he thought he was at "the old place on Woodward Avenue opposite William A. Moore's." He was referring to the Woodward/Farnsworth house, which had burned many years before the accident. However, once he was outside and walking, he had no problems. Since he was about eighty-one at the time and he came close to serious injury, his recovery was amazing. Even though he brushed off the idea of medical care, there must have been some if the wound was as serious as he said.

The current subdivision, the Merrill-Palmer subdivision (approved by the Wayne County Register of Deeds in 1923), is about the size of the town envisioned for the south end. In 1912, Woodward Avenue between Six Mile and Seven Mile Roads became the first mile of paved road in the United States. The Merrill-Palmer subdivision was the last of the five subdivisions of the original farm. The subdivisions are: Merrill-Palmer, Palmer Woods, Green

Acres, Sherwood Forest and the Detroit Golf Club. The subdivisions date from 1915 to 1923. The Merrill-Palmer subdivision is bounded by McNichols (Six Mile) on the south, Woodward Avenue on the east, Pontchartrain Boulevard on the west and Merrill Plaisance Drive on the north, adjacent to Covington Drive. Pontchartrain and Merrill Plaisance were planned as formal entrances to the public park, but that idea was discarded, and the two streets are set up like a boulevard with a large public space between them.

Elizabeth's will called on the Detroit Women's Club to sell the land and use it as an endowment for the Merrill-Palmer Institute. The club turned to Henry Glover Stevens for help. Stevens was born in Detroit on January 18, 1879. He was educated at Thatcher School in California and Hill School in Pennsylvania. He received a PhB from Sheffield Scientific School (Yale) in 1902 and a master's in forestry from Yale in 1903. He was the secretary of Stevens Land Company in 1906 and served as assistant treasurer for Iron Silver Mining Company.

Stevens and the women's club approached prominent architect Charles Agree for advice on how to develop the land. Agree was one of the top architects in Detroit. His designs for the Whittier and Belcrest Apartment Hotels put Detroit in the running as a home for excellence in this type of design.

I interviewed Agree in April 1980 (he died in 1982) and asked him about the development of Palmer Park. He remembered:

> So I told them at the time that they should sell the Six Mile frontage, put apartments on the Seven Mile frontage and keep the inside for homes. That's what I told them…If they sold it for apartments, they would get so much more for the land. I said, "But you're going to get too many people altogether in one spot. If you build an apartment, you put sixty people instead of two people in a home; you take just as much land." I said, "You're going to make it congested, and it won't be any good."

He continued:

> I argued with them at the time and told them what would be my advice: to leave the inside property and divide it into homesteads, not little homes but beautiful homes, and leave the park, of course, where it was and develop and sell the land on the main thoroughfares, that is, on Six Mile and Seven Mile Road, for apartments. That way, of course, that would be on the main thoroughfare where residents wouldn't be interested in building a home

Palmer Lodge, the first apartment building constructed in the district, was designed by Weidmaier and Chesnow in 1924. *Photo by Allan Machielse.*

on a main thoroughfare…I said that people wouldn't be interested to build homes on Seven Mile Road or on Six Mile Road, so I would take and develop apartments and the other I would advise to sell it, divide it into sixty-, seventy-, eighty-foot pieces of land for homes. They paid no attention. They said, "No, we can't come up because we get so much more by selling it for apartments." They would sell it for a home for $2,500 a lot; they can get possibly $15,000 for the same lot or two lots for $30,000. So that's what they began to do. They started to divide it on that basis. The first one they actually sold to develop was on the corner of Woodward and Covington.

The first apartment building, the Palmer Lodge at 225 Covington, was opened in 1924. Agree, in the above interview, remembered the apartment building boom of the 1920s. He told me, "In 1927, I did $10 million worth of construction. I was just a young architect. Do you know what that means in today's figures? They were all apartment buildings. I did nothing else. I didn't do any theater work. I didn't do any warehouses or stores. All I did was apartment houses. We used to get out an apartment a week out of that office."

Number 905 Merton Road (now demolished) shown in 1980. The building is attributed to the architectural firm of Weidmaier and Gay. *Courtesy of the Burton Historical Collection, Detroit Public Library.*

The Aberdeen (now demolished) was located at 17140 Third Avenue. The building's architect is unknown. *Courtesy of the Burton Historical Collection, Detroit Public Library.*

The last building to open in the district was the Blair House at 831–841 Merton. There were fifty-eight buildings, including five religious institutions and a one-story parking garage. There are currently fifty-six buildings with the loss of 905 Merton in a tragic arson fire and 17140 Third (the Aberdeen, circa 1926). There is one building at Six Mile and Second (the Delmar, 1925) that may be demolished soon, and farther down McNichols at Third was the Raleigh (1926). The Raleigh was demolished in 2014. The Delmar still stands, although it is in unstable condition. We do know that both were Neo-Georgian in style and were owned by developer Harry J. Pelavin.

Pelavin immigrated to the United States from eastern Ukraine prior to World War I. His brothers, Morris and Samuel, came with him. They invested heavily in Detroit apartment buildings. Many were in the Grand River/West Chicago area, which was largely Jewish, as was the west end of the Palmer Park district.

In 1980, most of the buildings in the district were listed on the National Register of Historic Places, based on research I did. I could only include buildings up to 1950; about half of the buildings were not eligible. In 2005, BVH Architecture, at the request of the City of Detroit and building on my research, had the remainder of the district added to the register.

As the apartment community grew, it came to be known as Palmer Park. It was considered an upscale community. Ads noted, "You played here as a child. Now come and live in the tranquil, country atmosphere of Palmer Park." The trolley rumbled down Woodward, turning around at the log house waiting room across from 225 Covington. The interurban from downtown Detroit to downtown Pontiac had a stop at the park.

There were upscale restaurants, antique shops and a movie theater within walking distance. The Keith-Albee Vaudeville chain (the largest in the country) built the RKO Uptown Keith-Albee Theatre. Later known as the Six Mile Uptown Theatre, it was on Woodward just below Six Mile. Edgar Bergen, Sophie Tucker and Bob Hope performed there with local acts fronting them. Detroiter R. Percival Pereira did major architectural work; J.N. Lustig of Graven and Magyar of Chicago completed the work. Charles Agree supervised the work. He had brought Graven and Magyar to Detroit to assist him with the design of the opulent Hollywood Theatre, which was considered a masterpiece for Agree.

Pereira's design was subdued, contrasted with the beauty of the Hollywood and the Fisher (in the Fisher Building in midtown Detroit). While the exterior was subdued, the interior was decorated in several imported

marbles for floors, columns and stairways; red and gold silk damask paneling chosen by Albee; two fireplaces; and an intricately sculpted plaster ceiling in the lobby. Contemporary newspaper articles claim the theater as the largest neighborhood theater in the state of Michigan, with an estimated 3,600 seats. It was also claimed to be the fourth largest theater overall in the state. There was a long two-story office block on the front of the building.

The *Free Press* reported that "the building is heated by indirect methods through vented stacks and blowers styled like mushrooms giving equal distribution of warmed fresh air for the winter and cool air for summer." This system was an Edward Albee invention involving the use of separate vents and blowers for each row of seats. The system was later adopted for use in the Houses of Congress in Washington, D.C. Also noteworthy was the system of indirect, recessed lighting of the interior domes, which was far-reaching for auditorium lighting in this period. After vaudeville died out, the theater became a movie house for second-run movies. It was owned briefly by the Nederlander Company. In November 1980, there was a small fire that left key parts of the auditorium in an unsafe condition. The auditorium was torn down, and the site is now a parking lot. The office block on the front remains. The discussion above is taken from a National Register of Historic Places application I filed in 1980 on behalf of the owners, who planned to use the listing as a means to attract new business partners to revive the theater.

The city created an eighteen-hole public golf course surrounding the park in the mid- and late 1920s. There was a movie theater within walking distance at Nevada and John R. Streets. By 1937, there were two more movie theaters. The Palmer Park (Charles Agree, 1937) was at the intersection of Hamilton and Six Mile. It was the first and perhaps only Detroit movie theater offering valet parking. It was demolished in the 1960s. The Krim (Charles Agree, 1937) is still standing at Woodward and Florence next to the vaudeville theater. It is now a church, and the lobby is the only original part of the building.

Not every building has been photographed for this book. This is due to the curvature of the streets and the way the buildings are situated. Some of the buildings pictured show the full edifice, while others have only a picture of detail work. These buildings are suggested as must-see sites by attendees of the annual architecture walking tour of the district held on the second Saturday in October. There is some discussion of other buildings that are architecturally significant, but often little to nothing is known about them.

The east and west sections of the district were developed first, primarily in the late 1920s. The buildings of the '30s and '40s fill the central section, and buildings of the '50s fill in other areas. The curvilinear Whitmore Road (originally called Strathmore Road) is the main street of the district. It crosses Third Avenue and sweeps westward, passing some of the iconic buildings of the district: 850 Whitmore's cool International style, 950 Whitmore's energetic Art Deco and 999 Whitmore's chic, cast concrete elegance. Here, in the heart of the district, we find the robust, rhythmic design that Detroit architects valued.

The district is unusual in that there are five religious institutions in one subdivision, with three of them forming a kind of piety hill section at Second and Whitmore. It was not unusual for there to be a church (usually Roman Catholic) in the middle of a subdivision. What is so unusual here is the proximity of the institutions, with St. Nicholas, Unity and the Fifth Church Christ Scientist laid out in a tight triangle at Second and Whitmore. Temple Israel dominates the west end of the district, and Grace hunkers down on Six Mile and Second Avenue.

There are other churches close to the district. One mile west of the area is Gesu Catholic Church and its school. This is a Spanish-style building with a red barrel tiled roof. Less than a mile to the east of the district, below Six Mile, is St. Benedict Catholic Church, a large, brick, octagonal building. The interior is all marble and boasts a large baldachin over the high altar. Just north of St. Benedict's is Emmanuel Episcopal, a tiny chapel on John R. and Nevada. Just past the entrance to the park, at Ponchartrain and West Seven Mile, sits St. John's Episcopal. North on Woodward and Eight Mile is St. John Byzantine Catholic Church. Holidays in the district are filled with incense and sound during the Orthodox Easter, and the Shofar can be heard on the High Holy Days. Within the original footprint of the farm, there are now two cemeteries. The larger is Woodlawn, a historic landmark and final resting place of civil rights icon Rosa Parks. She lies in a small chapel just inside the cemetery entrance. Around the chapel are the tombs of some of Detroit's best-known residents. You will find the Art Deco tomb of John and Horace Dodge and their wives. It is guarded by Art Deco lions. There are also several members of the Ford family interred on a private island. Colonel Frank Hecker is nearby. He was on the Panama Canal commission and the creator of this cemetery. Evergreen Cemetery is adjacent

Buildings of the 1920s and '30s

The 1920s were Detroit's boom time, seeing the development of almost all the buildings in downtown Detroit, most of the city's churches and schools and the mammoth Detroit Masonic Temple. The prevalent styles of the 1920s nationally were Tudor, Colonial, Spanish Revival, Moorish Revival and Mediterranean Revival. Carrère and Hastings of New York (the designers of the Merrill Fountain) and Franklin W. Smith of Boston championed the Mediterranean Revival style. The Detroit Moorish Revival style included architectural elements such as the horseshoe arch, which is often segmented; Solomonic (twisted) columns; small balconies tucked into corners overlooking courtyards; and generous use of tile work. The Luxor is the prime example of this detail.

The style is seen at 17255 Manderson, home of the Trocadero (Weidmaier and Gay, 1928), which has an entry that is a perfect Moorish Revival horseshoe arch. Number 300 Whitmore, home of Whitmore Plaza (Weidmaier and Gay, 1928), uses a small version of Solomonic columns, which are crowned with the horseshoe arch and a vertical keystone. These columns are modeled after the columns of the Court of the Lions in the Alhambra in Cordova, Spain. It is interesting to note that all of the known buildings of this style in Detroit date from 1928. There are none before and none after that year. There is a large group of these buildings in the district, and many more were found throughout the city. Unfortunately, the many buildings of this style outside the district have been demolished, leaving Palmer Park's as the prime examples of the style.

The Trocadero entry's Moorish arch is one of several found within the neighborhood. *Photo by Allan Machielse.*

Pilasters on 300 Whitmore, the Whitmore Plaza. *Photo by Allan Machielse.*

With the beginning of the Depression, all building in Detroit stopped until 1937, when the federal government removed some of the restraints on the business community. The economy rebounded quickly. Some economic analysts felt this happened too quickly and persuaded the federal government to re-regulate, resulting in a downturn. The same thing happened in 1938. In the 1930s, we see the flowering of the Art Deco style. Palmer Park's examples utilize cast concrete (999 Whitmore, Talmadge Coates Hughes, 1937, Art Deco style), clean brick styling (980 Whitmore, Robert West, 1938) and extravagant linear brickwork (950 Whitmore, Robert West, 1937).

In 1937, Robert West introduced the corner casement window as a significant design element in the district. The windows are small, paned and side hinged in pairs with a common frame. They are opened and closed with a crank or cam handle. With both halves open, the windows provide good air circulation, especially in a small apartment. The style is used extensively in the United Kingdom and Sweden. The Balmoral (361 Covington, Robert West, 1937) was the first building in the district to use the corner casement window. The building and its companion, the Fairlane (381 Covington, Robert West, 1937), were encouraged by the National Housing Act of 1934. The act established

Number 999 Whitmore, a poured-in-place concrete building. *Photo by Allan Machielse.*

The Park Central Apartments, 980 Whitmore, Robert West, 1939. *Photo by Allan Machielse.*

Number 950 Whitmore Road, Robert West, 1937. *Photo by Allan Machielse.*

the Federal Housing Administration (FHA). The FHA set national standards for residential builders and authorized federal mortgages that were financed privately. Economy and efficiency were the heralds of the FHA. The passage of the act was responsible for the all-too-short home building spurts of 1937 and 1938. Robert West was the master of the 1930s architecture in the district as Weidmaier and Gay owned the 1920s. But as of now, there is little information

on West. His listing in the directory of the American Institute of Architects (AIA) only gives his name. One can request an architect's application to the AIA, and this has proved helpful several times. But experience has shown if the directory listing is brief, there will be little information on the application.

The Palmer Lodge
225 Covington, Weidmaier and Chesnow, 1924, Tudor style

As noted previously, the Palmer Lodge was the first building opened. It is a Tudor Revival building with a slate tile roof and sloping roof on the façade. There is a section of half-timbering (also called strap work) on the fourth floor, which is typical of this style. Sometime after this building opened, John Gay began his partnership with Weidmaier after Weidmaier broke off from Louis Chesnow. In his July 1947 application to the AIA, Chesnow notes that he attended the University of Notre Dame for four and a half years, graduating in 1923 with a bachelor of architecture. Notre Dame gave him

The main entry at the Palmer Lodge, 225 Covington Road, designed by Weidmaier and Chesnow in 1924. *Photo by Allan Machielse.*

a scholarship, and he notes travel to the United States, Russia, France and Germany. It sounds like an ambitious adventure for a man we know to have been gravely ill most of his adult life, which nearly ruined his career. It is not known what diseases, other than serious back problems, plagued him.

For job training, he notes he was with Spier and Gehrke from 1921 to 1922 and J.W. Wilson from 1923 to 1924. He shows private practice from 1924 to 1931. It is during this period he worked with Weidmaier. The only record I find for his work during this period is his collaboration on the Palmer Lodge in 1924. Chesnow lists a position as resident engineer for the U.S. government from 1935 to 1936. From 1937 to 1939, he is shown at the Treasury Department Procurement Division and in private practice from 1939 to 1947. He died in December 1958. He was born in Slutzk, Belarus, on June 18, 1894.

John B. Gay applied for AIA membership in January 1942. He was born in Hamilton, Ontario, Canada, on March 21, 1892. He attended Hamilton High School, graduating in 1909. He then went to the Carnegie Institute of Technology, graduating in 1915. Under professional training, he notes service to Smith, Hinchman and Grylls; B.C. Wetzel; and three years with Albert Kahn, F.W. Weidmaier and the C.H. Mills Company. He notes "new partner, Weidmaier and Gay." He was granted emeritus status in the AIA in January 1969. The AIA published notice of his death in May 1973. In the previously quoted interview, Agree said that he felt Gay was a clever designer and Weidmaier was "the mechanic." Gay encouraged the brick masons to add designs in the brickwork, giving us the ability to spot a Weidmaier and Gay building easily.

Frank W. Weidmaier applied for AIA membership in March 1944. He was born in Detroit on August 29, 1882. He notes he attended grade and high school in Detroit. He listed training at Green and Wickes in Buffalo, New York, and Grylls and Gies in Detroit. He also said he commenced practice in 1909. He left the AIA membership on March 7, 1962, for reasons unknown. Weidmaier and Gay were responsible for at least thirteen apartment buildings and were considered throughout Detroit as the masters of the Moorish Revival style.

The descendants of the Palmer Lodge's owner, Tommy Davidson, remember visiting a spacious apartment on the third floor of the Woodward side of the building. They were impressed that Davidson kept a baby grand piano in the living room and still had space. There is also a local legend that members of Detroit's notorious Purple Gang used a "hidden room" in the basement as a hideout. One of Davidson's descendants told me that,

as a young girl, she found a gun behind a radiator while cleaning a vacated apartment. Davidson also owned the parking garage on Third between Merton and Whitmore. This one-story, unobtrusive building was on Third Avenue between Whitmore Road and Alwyne Lane. Residents dropped off their cars at night and had them delivered to their doors the next day, washed, polished and gassed up. There was a semicircular glass-walled showroom at the front of the building when it was used as a new car showroom in the 1940s. That showroom is missing, having been torn off a decade or so ago. The rest of the building is currently being used as a warehouse.

I have a personal note that shows how committed the owners of these buildings were then and now. It was the spring of 1978, and I was driving south on Woodward with a friend. As we came up to Seven Mile, we saw a huge plume of smoke. As we proceeded, we saw a large crowd of people and several fire trucks in front of 225 Covington. Smoke was pouring from the roof of the west wing. I parked and saw a friend. I asked him why no one was going inside to fight the fire. His understanding was that it was an unsafe condition and highly dangerous because no one knew where the fire was in the attic. They thought if they went inside immediately, they would be trapped when the roof collapsed. He had just said that when the smoke parted and there was a huge boom. The wood framing that held up the slate-tiled roof had burned through, and the roof collapsed. The fire department knocked down the fire in minutes.

The building lost the roof of the west wing, the west wing apartments and a section of the third floor. We thought this was it for the lodge. In Detroit at that time, if a building suffered major damage like this, it was abandoned. But within six months, the west wing was rebuilt. Even the roof tile was color-matched to blend with the original slate roof. There were few places in Detroit that were valued so highly.

Currently, there are owners who have buildings that have been passed down in the family for over sixty years. Another owner holds eleven buildings. Each one has been totally gut renovated to the bricks. Apartments were resized, and floor plans that were outdated have been rebuilt. They have retained lobbies with paint matching the original colors. Exterior historic details have also been saved. It is the commitment of the property owners from the day they entered the area that has kept it going. Someday, I hope the M-1 light rail will reach the area. Then we will have the kind of convenience that the original residents had in their day.

Green and yellow porcelain enameled steel panels at the Florentine apartments, 750 Covington Road, designed by Weidmaier and Gay in 1926. *Photo by Allan Machielse.*

The Florentine
757 Covington, Weidmaier and Gay, 1926, Mediterranean style

The Florentine is known in the district for its bold coloring. The brick is a sunny yellow; the enameled steel Art Deco entry is a light green. Red barrel tiles cover the roof. There are yellow and green enameled pannels on the fourth floor. There are two-story twisted columns on the façade. In the rear of the building, there is a private garden and a large screened balcony. Often in the district we see one apartment that is included in a building and is distinct from the others. Local lore holds that these were designed for the owner of the building. The units may have had top-of-the-line appliances, double-height rooms, larger dining areas or screened porches. In the past, living in the "original owner's apartment" raised one's status.

The Walbri Court
1001 Covington, Albert Kahn, 1925, Georgian style

A restrained Georgian style, the Walbri Court was constructed in 1925 for Walter Briggs, owner of Briggs Manufacturing, the Detroit Tigers (1919–35)

The Walbri Court, 1001 Covington Road, designed by Albert Kahn in 1925. *Photo by Allan Machielse.*

and Briggs Field, where the team played. The building name is a contraction of Walter Briggs. This way of naming a building was common in Detroit. Briggs was concerned that his employees and players with children were having trouble finding decent housing that accepted children. He also wanted children to have access to outdoor recreation. The Burton Historic Collection has a prospectus booklet for the Walbri Court. On the first page is a notice that you must have at least one child under five years of age in order to rent a unit.

In response, Kahn designed a sixteen-unit brick and stone building. The building has a steel frame with poured concrete floors between units and the elevator. Around the corner, at 999 Whitmore, is another building that used concrete technology. There was a children's theater with a stage on the ground floor. The Walbri is one of three five-story buildings in the district, whereas the others were only two and three stories. The scaling is so good that an observer does not realize they are five-story buildings.

The units are spacious and average three thousand square feet (including private storage and laundry facilities for each unit). One of the four

bedrooms is soundproofed and was to be used as a nursery. There are maid's quarters off the kitchen. The large formal living room with a wood-burning fireplace balances the large solarium at the other end of the unit. The four bedrooms open onto a long hall linking the solarium and living rooms. There are three baths (one for each pair of bedrooms and one in the maid's quarters). The units are designed so there are no common walls with another unit other than the entry rooms. The kitchen has a communicating door with the entry hall so that the maid can answer the door without going outside the kitchen and entry hall, so as to not disturb the family. A small paned door in the hallway can be closed to cut off the bedrooms, baths and solarium from the rest of the unit. This is the type of unit one expects to find on Fifth Avenue or the Upper East Side in New York City. The lobby is a dark-paneled room with a marble staircase and wrought-iron rail.

Kahn (who was an apprentice with Mason and Rice in the 1880s) was internationally known for his designs for auto plants and many gracious homes, as well as stunning office buildings. These included the massive Fisher Building (1928) in Detroit's New Center area and the world headquarters for S.S. Kresge (1927), which fronted on Cass Park on the edge of downtown Detroit. Kahn designed only five known apartment buildings in his career. Four remain, including the Walbri Court.

The Luxor
17655 Manderson, Weidmaier and Gay, 1928, Moorish Revival style

The Luxor is an outstanding example of the Moorish Revival style, with Moorish arches and impressive original tile work inside and outside. The iridescent gold and blue tile work of the entrance is a product called Flint Faience tile produced by the Champion Spark Plug Company in the 1920s. The company had excess kiln capacity, and rather than waste space, it produced this tile. The mail lobby is entirely Flint Faience and has been untouched since 1928. The main lobby retains almost all of its original trim colors, including the painted ceiling and stenciled beams. Only the lower section of the lobby walls has been painted over the original color. The elevator is original and still operable.

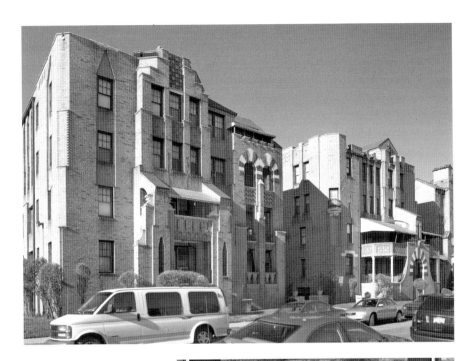

Above: The Luxor, 17655 Manderson Road, designed by Weidmaier and Gay in 1928. *Photo by Allan Machielse.*

Right: The front door of the Luxor Apartments is Moorish in design and includes Flint Faience tile work by the Champion Spark Plug Company. *Photo by Allan Machielse.*

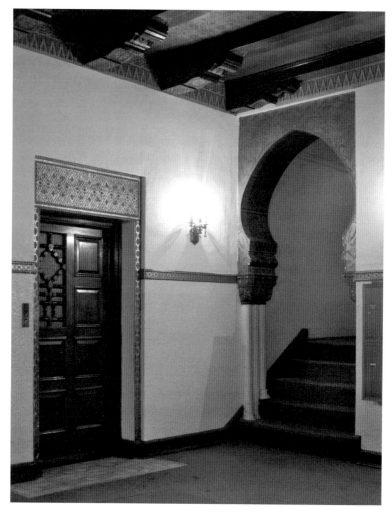

The inner lobby of the Luxor, showing the stenciled beamed ceiling, original wood elevator door and Moorish arch leading to one of the apartment wings. *Photo by Allan Machielse.*

The El Dorado
17675 Manderson, Weidmaier and Gay, 1928, Moorish Revival style

The El Dorado is one of three Moorish Revival–style buildings on Manderson between Covington and Whitmore. The El Dorado has a private garden in the front courtyard and deep balconies overlooking the entrance.

The Trocadero
17725 Manderson, Weidmaier and Gay, 1928, Moorish Revival style

The Trocadero is one of the finest examples of the Moorish Revival style. It boasts huge front porches with archways in the segmented Moorish arch style. The entryway is crowned by a perfect Moorish horseshoe-shaped arch. The building boasts some of the finest barrel arch tile work in the district. The apartments are spacious, with large dining rooms and comfortable bedrooms.

The Whitmore Plaza
300 Whitmore, Weidmaier and Gay, 1928, Moorish Revival style

The Whitmore is one of the most opulently decorated buildings in the area and among Weidmaier and Gay's finest designs. The front door surround is cast concrete, tinted a buff reddish color. The slope of the entry door is reminiscent of Egyptian tomb doors. The façade is adorned with black and white zigzagged brickwork in the elevations between the windows. This is a typical Weidmaier and Gay treatment of the elevations under the windows. Elsewhere in the district is similar brickwork treatment under windows, but it is in orange and red. There are pilasters on the first-floor façade that are adorned with cast-concrete griffins.

The Whitmore Plaza, 300 Whitmore Road, designed by Weidmaier and Gay in 1928. *Photo by Allan Machielse.*

Left: The Egyptian Revival door at the Whitmore Plaza. *Photo by Allan Machielse.*

Below: Griffins cap a series of pilasters at the Whitmore Plaza. *Photo by Allan Machielse.*

La Vogue
225 Merton, architect unknown, 1929, Eclectic style

La Vogue is one of the most elegantly detailed buildings in the district. It was built for Dr. David Weingarten and held by his family until its sale in 2007. This is the only building held by one family in the area's history. La Vogue is accented in "clinker brick" set into a random pattern. The façade also features a round tile mosaic of a sailing ship set above the door. The lobby is true Art Deco, with a built-in couch, original paint on the arches and an Art Deco fireplace. Unfortunately, its Deco chandelier was stolen in 2007. This is the first of eleven buildings being gut renovated by new owners who have saved historic details whenever possible and gone to great lengths to match window treatments. The new owners have left the original Art Deco lobby intact and have painted detail in colors that echo the original paint. The architect is sometimes listed as Cyril Schley. He designed two houses in the nearby Detroit Golf Club subdivision. His family has done considerable research on his work. They do not list La Vogue. During a tour of Schley's work I conducted for his family two years ago, there was some debate as to whether this should be included. If he could get permission, he would "sign" a building with an elongated *S*. This

La Vogue, 225 Merton Road, architect unknown, was built in 1929. *Photo by Allan Machielse.*

The front entrance at La Vogue. *Photo by Allan Machielse.*

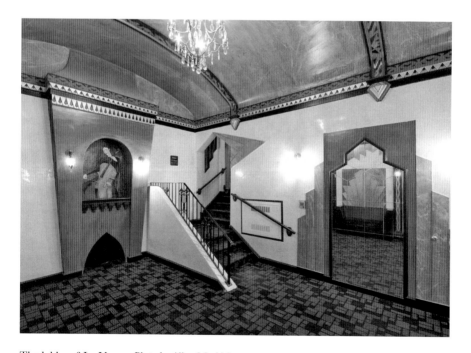

The lobby of La Vogue. *Photo by Allan Machielse.*

was done on one of the houses in the Golf Club subdivision. La Vogue has an elongated *S*, but his family said the emblem is displayed incorrectly. There is a large upright *S*, not the elongated, fluid *S* that Schley used on the plans for Detroit's Symphony Hall and others.

999 Whitmore
999 Whitmore, Talmadge Hughes, 1937, Art Deco style

Architect Talmadge C. Hughes considered 999 Whitmore to be his masterpiece. The building appears on the cover of a 1937 issue of the *Bulletin of the Detroit Chapter of the American Institute of Architects*. It was among the first cast-concrete residential structures in Detroit. The original building permit called for a four-story brick building. But a few weeks after that permit was issued, it was canceled, and I cannot find

Number 999 Whitmore Road in 1941. It was designed by architect Talmadge C. Hughes in 1937. *Courtesy of the Walter P. Reuther Library, Wayne State University.*

a reason. It is speculated that Hughes was influenced by a cast-concrete structure being built for Sears just south of the district. Where the usual technology was to use poured concrete and cover it with brick or stone veneer, 999 is completely cast concrete. These are two-story town house apartments stacked one above the other. There is a roof garden with a fountain that once held three small bronzes by artist Marshall Fredericks (who also created the *Spirit of Detroit* in downtown Detroit). In a 1979 letter to me, Fredericks said he created a Japanese goldfish, a lizard and a frog. He said there was another cast-bronze piece in the lobby called *Torso of a Dancer*. Unfortunately, all are missing. Fredericks did remember that *Torso of a Dancer* was sold at auction, but he did not have a date for that auction.

From the AIA directory for 1956, we learn Hughes was born in Coates Bend, Etowah County, Alabama, on November 17, 1887. He graduated from the Alabama Polytech Institute with a BSA. He studied at Columbia University graduate studies and traveled extensively. Hughes worked for Smith, Hinchman and Grylls; Albert Kahn; and H. Jerome Darling. He listed "Detroit's only all duplex apartment building at 999 Whitmore" among his projects. He won Best of the Year Awards for the Ryan Theatre in Detroit and the Rapids Theatre in Eaton Rapids, Michigan.

Beneath the windows are sections of what looks like marble. It is really a pigmented structural glass called Vitrolite. This product was pigmented glass, made first by Pilkington Brothers in the United Kingdom. It was made by the Vitrolite Company (1908–35) and then by Libby-Owens-Ford (1935–47) in the United States. The glass was marketed as Sani Onyx (or Rox) by the Marietta Manufacturing Company from 1900 onward and as Carrara Glass by the Penn-American Plate Glass Company after 1906. The company claimed to be the first producer of pigmented structural glass. The term "vitreous marble" was used by Marietta Manufacturing as a generic label for pigmented structural glass. It came in a variety of colors and, because of its non-porous nature, was used extensively in restrooms and operating rooms. It is no longer made, but a stockpile does exist. The first large-scale interior application of the product was when architect Cass Gilbert sheathed the restroom of the Woolworth Building in New York.

Hughes became very involved in the activities of the AIA, serving as its secretary for many years. Subsequently, he designed few buildings. Currently, five homes have been identified as his work in Grosse Pointe Woods and the area of the city of Grosse Pointe.

Palmer Park Presbyterian Church
642 West McNichols, Lane and Davenport, 1921, Neo-Gothic style

Palmer Park Presbyterian Church is overshadowed by its neighbor, the Delmar Apartments, on McNichols at Second. It is a departure for its designers, Lane and Davenport (later Lane, Davenport and Peterson). The firm is better known for its school complexes in small and mid-sized towns in mid- and northern Michigan (such as Grass Lake and Saginaw). The church merged with Highland Park Presbyterian to become Park United Presbyterian Church on January 9, 1972. The merged congregation met in the city of Highland Park (just south of Palmer Park). Grace Christian Methodist purchased the building in 1972 and is still meeting there.

This is a rectangular, brick, Neo-Gothic church. The façade has a central bay flanked by two buttress-like elements that have the double door entrance with a segmental arch and large tracery pointed arch. The sides are six bays long, with one pointed arch window in each bay.

Buildings of the 1930s and '40s

Park Plaza
825 Whitmore, I.M. Lewis, 1946, Art Deco style

Park Plaza is an excellent example of the creative use of light and shadow. Approaching the building, you see a long glass/brick wall with a curved edge. This long wall pulls you into the mail lobby. This is a short paneled hall with curved moldings on the doors and walls. This lobby is slightly dim. Pass through the door and you see that Isadore M. Lewis, the architect, had a problem in the lobby. If he designed the usual lobby space, it would be a dark room. Any window would look out onto the back of the old parking garage to the south. He built a large glass brick window in the back wall, which floods the room with light. The blocks are in an Art Deco style, with the edge echoing the setbacks of the building on the Third Avenue façade. Throughout the building, the corner wall edges are rounded, repeating the curve of the glass block wall that defines the entrance, except for one wall that cuts into the hallway.

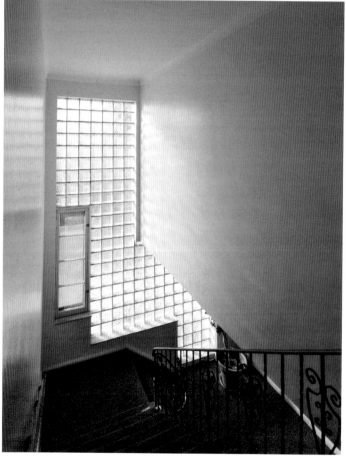

Above: Park Plaza, 825 Whitmore Road, designed by Isadore M. Lewis in 1946. *Photo by Allan Machielse.*

Left: A two-story window in the stairway at the Park Plaza. *Photo by Allan Machielse.*

Park Central Apartments
980 Whitmore, Robert West, 1938, Art Deco style

This building is a profusion of right angles that display a Streamline-style influence in an Art Deco building. It has glass block sidelights at the front entry, which continue to a single row of blocks that soars upward to the roof. It has generously spaced apartments, with the front units having cloth awnings on the balconies and screens on the first floor.

950 Whitmore
950 Whitmore, Robert West, 1938, Art Deco style

Compare 950 Whitmore with 980 Whitmore just next door. This building has a profusion of linear detail and uses metal corner casement windows and orange brickwork in horizontal stringcourses. The brickwork lifts the eye upward and gives considerable energy to the design. The building still has the hardware that was used for its cloth awnings, which have been removed.

900 Whitmore
900 Whitmore Robert West, 1938, Art Deco/International style

This is an example of a transitional design with the architect moving from Art Deco to the International style seen next door at 950 Whitmore. The architect is using details more like the Art Deco, with sharp lines in the wall treatments. Instead of using a U-shaped entry, he uses an oval and then breaks it up with sharp angles. We also see the corner casement window and some Vitrolite in some of the elevations under windows in the courtyard.

The Balmoral
361 Covington, Robert West, 1937, Moderne style

This four-story yellow and orange brick building is supported by cinder block and steel frame construction. The front façade has rusticated stone on the first floor. The main entrance is framed with smooth, squared limestone that encloses the original wood and glass doors. There is a limestone relief of a stylized partial sunburst. The Balmoral was the first building in the district to

use the corner casement windows. It has twenty-four very small apartments that are ideal for retirees, college students and those looking for their first apartment. West became a master at using small lots nestled closely to other buildings.

For more examples of this styling, see the Gilbert Apartments (now Boyce apartments) at 17701 Manderson and 951 Whitmore. The Boyce has four balconies on the front. The lower two are screened and the upper two originally had awnings. The Boyce has strong Art Deco accents and is literally squeezed into the space between the Trocadero and the El Dorado, both of which are large buildings. The building at 951 Whitmore is also squeezed between La Fer and 999 Whitmore. Both use corner casement windows and strong lateral designs in the brickwork. Both are on single standard lots (approximately thirty feet wide and sixty to one hundred feet deep).

The Fairlane
381 Covington, Robert West, 1937, Moderne style

The Fairlane is a four-story, yellow and orange brick building and is supported by steel frame and cinder block. The building is a near twin for the Balmoral except it is simpler in design. The building has multi-paned casement windows at the east and west façades; the front façade has vertical single panes of glass. The front façade also has rusticated stone on the first floor but only on the east side of the façade. There is also a second-floor balcony with a limestone framed doorway above the first-floor entry.

Fifth Church Christ Scientist
624 Whitmore Road, Derrick and Gamber, 1937, Colonial style

The Fifth Church Christ Scientist was designed in the Georgian Revival style by the firm of Derrick and Gamber. It is now the education building for Unity Temple Detroit directly across Whitmore Road.

Little is known about Bronson V. Gamber except that he graduated from the University of Pennsylvania and joined the firm of Robert O. Derrick sometime in the 1930s. Derrick was considered one of Detroit's leading architects. His was born in Buffalo, New York, on July 28, 1890. Both his parents died when he was still young. He earned a bachelor of arts at Yale, graduating in 1913. In 1917, he became a registered architect. He served at Fort Sheridan and spent a year overseas, where he saw action, particularly

The Fifth Church of Christ Scientist, designed by Derrick and Gamber in 1937. Unity Temple can be seen beyond. *Photo by Allan Machielse.*

in the Toul sector and the Meuse-Argonne offensive. He came to Detroit in February 1921, where he became a member of Brown, Preston and Derrick, then Brown and Derrick and then Robert O. Derrick Incorporated. Sometime in the 1930s, it became Derrick and Gamber. There are few examples of their collaboration other than the Fifth Church Christ Scientist. Derrick's Colonial designs found a home in the Grosse Pointes, the suburbs to the east of Detroit where Henry Ford II and other industrialists lived.

Henry Ford I contracted with Derrick and Gamber to oversee the construction of an exact copy of Independence Hall in Philadelphia that was built at Greenfield Village in Dearborn, Michigan. It is the centerpiece of the park, which includes the Wright brothers' bicycle shop and dozens of other buildings collected by Ford. It was called the Henry Ford Museum and now is known as the Henry Ford.

The church is redbrick with white Palladian windows with keystones. It has five windows on each long wall of the auditorium with elaborate quoins and other brick ornamentation. The slate entry walk leads to a slate floored entry with three brick columns with semicircular arches and keystones. There are broken pediments over the doors. It has a louvered white wooden steeple and could be comfortably set in any New England town green. Its design probably influenced the American Colonial–style Slater Apartments, which are directly next door to it.

Derrick's Punch and Judy Theater in Grosse Pointe (opened on January 29, 1930) was his most remembered building. Its design was drawn from existing buildings in New England. The interior was modeled after the meeting rooms of towns. There was a comfortable lounge on the mezzanine and several open-grate fireplaces contributing to the atmosphere of being in a luxurious home. The building was demolished in the 1980s.

Detroit Unity Temple
Second and Whitmore, Arnold and Fuger, 1951–56, Art Deco style

Unity Temple, designed by Arnold and Fuger architects in 1951. *Photo by Allan Machielse.*

The Detroit Unity Temple is a rectangle of white marble. The building combines Art Deco and Art Moderne influences that carry out the simplicity of Unity's philosophy. The windows of the south façade have a patterned framework with heavy spandrels. The interior continues the verticality of the exterior. Fuger, the main designer for the structure, considered it his masterpiece. Jacob Strobel and Sons constructed the building. Representatives from all over the country attended the 1956 dedication, including Lowell Fillmore, son of the founders of Unity.

The most prominent leader of Unity Detroit was Eric Butterworth. He was considered a legend and was the author of sixteen bestselling books on Unity philosophy. He came to Detroit, where he led services at the Detroit Institute of the Arts auditorium for a brief time. Butterworth built the congregation, welcoming two thousand people to Sunday services. He wrote his first book, *Unity: A Quest for Truth*, while in Detroit. In 1961, he went to New York City and built another successful Unity community.

Temple Israel
17502 Manderson Road, William Kapp, 1951–60, Art Moderne style

The Temple Israel was designed by William Kapp, the architect of Meadowbrook Hall, the Detroit Historical Museum, the University Club, the Players Club and the Dossin Museum on Belle Isle. Kapp designed this classic synagogue with two large columns flanking the door. The columns are copies of the two that stood at the doors of Solomon's temple. The column on the left was called Boaz, and the right-hand one was called Jaykin. There are large stained-glass windows in the sanctuary featuring Moses and the Prophets. The building is set far back on its site. Any closer to the streets around it, and the building would have seemed oppressive. The 1951 dedication ceremony for phase one (the sanctuary, offices and social facilities) saw the mayor of Detroit, Albert Cobo, and Governor G. Mennen Williams attend the four-day celebration.

Rabbi Leon Fram founded Temple Israel in 1941. The congregation was a split from Temple Beth-El, Detroit's oldest Jewish congregation. Rabbi Fram had been an associate rabbi at Temple Israel. He had been extremely active in liberal causes. The congregation held services in the Detroit Institute of

Temple Israel, designed by William Kapp in 1960. *Photo by Allan Machielse.*

Arts and soon became one of Detroit's largest Jewish congregations. Many of its members moved to the district, mainly on the west side (Manderson Road). When I lived at 980 Whitmore (around the corner from the temple) in the mid-1980s, there was still a mezuzah on the doorpost. Temple Israel left Detroit in 1979.

Louis Schostak, a prominent local builder, headed the building committee that encouraged construction in the Palmer Park District. The committee chose William Kapp as the architect. He was associated with Smith, Hinchman and Grylls, one of Detroit's oldest architectural firms, from the 1920s until 1941, when he set up his own firm.

In addition to the front columns, there is a large rotunda containing the sanctuary. There is a copper frieze around the rotunda roof. Lion heads can be seen along the frieze.

Buildings of the 1950s and '60s

Blair House
831–841 Merton, Joseph Savin, April 1964,
Mid-Century Modern style

In a short 1980 interview I had with Dr. Savin, he noted that this building has two loft apartments, two flats with two bedrooms, two efficiency units and two town house units. The question was: could these varying types of units work together? The building overlooks a shaded, sunken garden, both front and rear. The roof sundeck was accessible to all tenants. The building is now abandoned.

St. Nicholas Greek Orthodox Church
Second and Merton, Alexander K. Eugenides and Harold Fisher,
1951–68, Byzantine style

St. Nicholas Greek Orthodox Church (now the Church of Jesus Christ of Latter Day Saints) was founded in 1936 at the home of Gus Petropoulos at 274 Nevada, which is about a mile east of the current church. The first services were held at 242 Victor. In 1937, the congregation purchased a bank at Tuxedo and Hamilton Streets. The church was changed to St. Nicholas

St. Nicholas Greek Orthodox Church (now the Church of Jesus Christ of Latter Day Saints) stands at the corner of Second and Merton and was designed by Harold Fisher and Alexander Eugenides, 1951–68. *Photo by Allan Machielse.*

An aerial shot looking east, 1949. This photo was taken for St. Nicholas Greek Orthodox just before its groundbreaking. Third Avenue is at the bottom right of the photo. Second Avenue can be seen at the top. Notice the victory gardens along Third and Whitmore. The church would be on the triangular lot across Second from the Fifth Church of Christ Scientist. The public park is at the bottom left of the image. *From the collection of Allan Machielse.*

Hellenic Orthodox Church. In 1943, land was purchased in Palmer Park at Merton and Second. Architect Alexander K. Eugenides drew up plans for the first phase. Construction of the lower level was completed in 1951. The church was completed under the supervision of Louis Christopoulous, chair of the building committee. The church was consecrated during a three-day observance from May 1–3, 1953. It is designed in the Byzantine style; the interior of the church has icons painted by George Gloats and Constantine Yioussis. In 1968, a recreation facility, including thirteen Sunday school classrooms, was added. The new church at 760 West Wattles Road was consecrated on May 19, 1996.

The Covington Arms
333 Covington, Paul Tilds, 1955, International style

Paul Tilds was born in Chicago on January 22, 1904, and died in Detroit in February 1977. He studied at the Armour Institute of Technology and took his BS in architecture from the University of Michigan. He worked with Louis Kamper, C. Howard Crane and Malcolmson and Higginbotham. A five-story brick building with limestone trim and designed in a Modernistic style, the Covington Arms is the first apartment building in Michigan that was built as a cooperative, with sixteen luxury units custom designed for each owner. The porches on each unit originally had jalousie windows. The circular drive leads to a covered masonry entrance in front of a recessed marble wall with the building name in raised letters.

Louis H. Schostak was one of Palmer Park's leading figures. In 1955, Schostak—together with David Tann, president of Congress Tool and Die, and Nathan Fishman of Star Steel—built 333 Covington. They were tired of maintaining large houses. Each unit had a library, a heated enclosed porch, air conditioning and access to indoor parking.

Schostak's, Tann's and Fishman's apartments were located on the top floor. Tann's apartment reportedly had marble floors, a double-sided fireplace and Japanese Shoji doors at each end. Louis Blumburg, president of Blumburg Brothers Insurance Company; Daniel A. Laven, president of Central Heating Company; and William Boesky, the well-known owner of Boesky's Deli and the Brass Rail Chop House, were among the first owners. Schostak, one of the founders of Schostak Brothers and Company, was instrumental in the construction of Temple Israel. Schostak Brothers would go on to develop

Covington Arms, 333 Covington Road, designed by Paul Tilds in 1955. *Photo by Allan Machielse.*

much of the city of Southfield. Schostak Brothers is today one of the state's largest real estate companies. The company has undertaken the renovation of historic Merchants Row in downtown Detroit, which has contributed to the revitalization of the area.

Manor House
660 Whitmore, Paul Tilds, 1949, International style

Number 660 Whitmore is an elegant International-style brick building with jalousie windows and underground parking (the only building in the district to have this detail). The rear four apartments are the only ones with access to the garden built over the garage. This building is a near copy of 333 Covington. Although tenants did not customize their units before moving in, many of them did small renovations so that they felt they had the same liberty in choosing the design as the tenants of the Covington Arms.

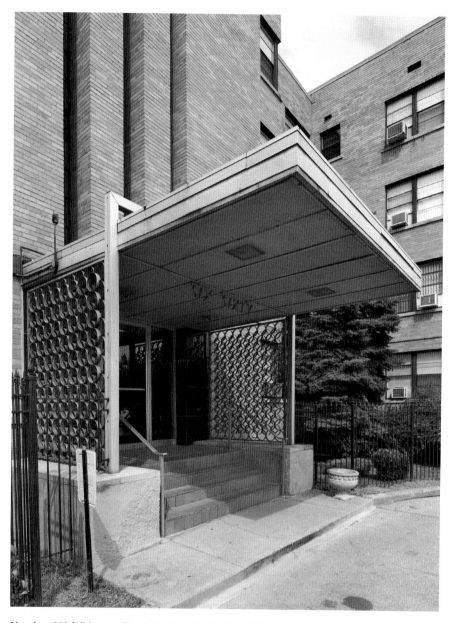

Number 660 Whitmore Road, designed by Paul Tilds in the International style in 1949. *Photo by Allan Machielse.*

The Slater Apartments
653–701 Whitmore, Weidmaier and Gay, 1950,
American Colonial style

The Slater Apartments are an example of how the district's architects created a sense of mystery. This is a half-block-long, hip-roofed redbrick Colonial-style building that sits next to the Unity Center for Holistic Living. The building has a variety of setbacks and stone trim to break up the length of the building. Most of the apartment buildings in the district and Detroit are U-shaped, with a wall or gate that draws the visitor into the "embrace" of the building's wings. When the visitor steps into the courtyard, he has a sense of being in a quieter place, often a hidden space. There are two entry doors at the upper corners of the courtyard that provide access to the wings. The front door is ahead. Its trim work may be unique to itself or an expression of the highest example of this style. There is also some vertical detailing that draws the eye up to the roofline. Here we often find a balustrade with decorative urns, Tudor twisted chimneys or some other detail. The main entry to the Slater leads the eye up, but the building does not have the balustrade. The Slater is another FHA-approved building.

Weidmaier and Gay took the classical U-shape, opened it up and stretched it flat. There is a low brick wall running the length of the building. Up a flight of three step is a plaza that reminds the visitor of a bridge. Below

The Slater Apartments, 653–701 Whitmore Road, designed by Weidmaier and Gay in 1950. *Photo by Allan Machielse.*

Above: The central entrance at 653–701 Whitmore Road. *Photo by Allan Machielse.*

Left: One of the smaller, more private entrances to the Slater Apartments located at either end of the building. *Photo by Allan Machielse.*

and on each side of this "bridge" plaza are three concrete planters, each one half the size of the last. There are also the corner windows like the casement windows seen previously. Here they are rendered in wooden, double-hung windows. There are the familiar chevrons that are distinctive of Weidmaier and Gay buildings, but on the Slater they are the same color as the walls. This is unlike the colorful contrast of the detail in the 1920s Moorish Revival work of that firm.

Nine large, wooden-trimmed, frosted-glass windows frame the front door. The door has three square windows. Each has an iron cage around it. At each end of the building are the private entrances. These have natural wood supports forming the roof and walls, with sandstone trim and rows of small windows that can be opened and closed for ventilation. These entrances are dark and enclosed, contrasting the openness of the main entry. The front door is also defined by several rows of brick quoins. Quoins are usually masonry blocks at the edges of a wall and may be either stone or brick. Here, they give the impression of stone detailing. They are two bricks thick with the bricks laid alternately on their long sides and short sides, providing contrast. Larger quoins are seen on adjacent Fifth Church Christ Scientist (Unity Center for Holistic Living). Since the Christian Church was built before the Slater, I am assuming it was the inspiration to use the detail on the apartment building.

There is another interesting detail that isn't noticeable at first: the use of threes. Visitors enter the courtyard by three steps. There are three planters on each side of the entry. There are nine windows around the door. There are three entrances, one central and one at each end of the building. In the U-shaped building, these would be the two side doors into the courtyard. The building's styling leaves the visitor with a strong sense of strength and presence.

World War II housing demand gave us the "garden apartment." These are typically two- or three-story, multiple-family buildings. The units were arranged to afford privacy, sunlight and fresh air. This design provided separation from the street traffic, with many having balconies overlooking landscaped gardens. The 1960s brought the much-maligned "motel-style" apartment buildings. These were usually designed with brick walls, with each unit opening onto a common walkway; the picture window is usually broad, and the roofs are flat. The difference between these and the postwar buildings is that the earlier buildings are better-designed and utilized better construction materials. The district has good examples of how this type of building can be almost Miesian with a light, airy look.

Additional Buildings of Note

631–711 Covington
631–711 Covington, architect unknown, 1944, Neoclassical style

This is a long, two-story brick Neoclassical-style building constructed in nine sections. Each section contains four units and has its own entrance, with each doorway designed with different detailing, such as broken pediment crowns, sidelights, shutters and covered porticos. The center section is composed of permastone, with a two-story, pedimented central portico supported by four square columns. This building takes up most of the block of Covington between Second and Third Avenues. It is also one of the best examples of the American Colonial style in the city.

Rosemor (now Metropolitan Apartments)
761 Whitmore, Weidmaier and Gay, 1948, Modern style

This is a two-story buff brick, irregularly shaped building at the corner of Whitmore and Third. It is a thirty-unit building that has two entrances, one on Whitmore and one on Third. It is similar in style to the Palmer Court, 941–1001 Merton, and the Merton Road Apartments, 1000 Merton.

Merton House
820 Merton, architect unknown, 1962, developed by Practical Home Builders, Modern style

This is a fairly typical "motel-style" building. The buildings of this type in the district tend to be a little better designed than elsewhere in the city. The Merton House once was the only building in the district with a swimming pool. A sunken garden has replaced the pool. The building has covered galleries with decorative metal railings overlooking the garden. The first-floor gallery has an accordion-fold entry canopy supported by steel pipe columns.

810–818 Whitmore
810–818 Whitmore, architect unknown, 1960s, Modern style

These are four co-op buildings that sit at the intersection of Whitmore and Third. They were built as rentals but became a co-op (333 Covington differs in that it was built as a co-op). Usually, these kinds of buildings are undistinguished redbrick with aluminum windows and flat tar roofs. This development is different in that it was split into four separate buildings. A flat roof of white T-shaped metal provides shelter for the center courtyard formed by the buildings. The courtyard has large, wooden doors with a long window and ashlar stone forming planting beds. These buildings are distinguished because they have a little more style than the usual buildings of this period.

Hampshire House
885 Covington, architect unknown, 1949, Modern style

This four-story L-shaped brick building has rows of large casement windows, and the main entrance is covered with a metal canopy supported by multiple metal poles. Its fifty-six units are efficiencies. The main entrance is off center and is surrounded by white marble slabs.

Cambridge House
931 Covington, architect unknown, 1949, Modern style

This building is almost identical to 885 Covington except it has seventy-one units. While neither of these buildings can be called outstanding architecturally, they are typical of the kind of structures being built with FHA funds to address the postwar housing needs. Even at that, there are interesting touches showing an awareness of their surroundings.

The Seville
750 Whitmore, architect unknown, 1927, Collegiate Gothic style

The Seville was built as efficiency apartments. It has been carefully reconfigured into larger units. From the outside, it appears bland and without decoration. The architect made up for that in the lobby. The Seville has one of two double-height

The Seville Apartments, 750 Whitmore Road, architect unknown, designed in 1927. *Photo by Allan Machielse.*

lobbies in the area (825 Whitmore is the other). The first floor of the lobby is marble and dark wood paneling. The upper wall is plaster. The grand marble staircase leads to three lancet openings, with wrought-iron railing up the stairs to the lancets. The ceiling is pressed plaster painted in delicate pastel colors.

The Carole Jean Apartments
17524 Third, Weidmaier and Gay, circa 1955, Modern style

The Carole Jean Apartments is an L-shaped building sitting elegantly on a small lot. This is one of Weidmaier and Gay's last buildings before their retirement in 1956. It is called the Carole Jean Apartments after the owner's wife. It is a good example of how the architects of the district worked on problem sites. This building is on a small lot on Third Avenue. It is between the much larger 757 Covington (the Florentine) and 750 Whitmore. If the front entrance was on Third Avenue, the building would have been smaller and squeezed into the space. So the architects

Number 17524 Third Avenue, designed by Weidmaier and Gay circa 1955. *Photo by Allan Machielse.*

set an oblong building on the north end of the lot, with its short side to the street. The entrance is hidden along the side of the building in the back section. The building is set right against the lot line for the Florentine, leaving the rest of the lot as a lawn, which breaks the mass of the three buildings.

17481 and 17487 Alwyne Lane
17481 and 17487 Alwyne Lane, architect unknown, circa 1945, Neo-Tudor style

These two detached, flat buildings are examples of the type of homes originally planned for the district. They were attached by a walkway in the 1980s, when it was used as Detroit's first AIDS hospice. Unfortunately, these buildings are also typical of the blight that has destroyed such large areas of Detroit. They are boarded up, and all doors and details like outside lighting fixtures are gone. Originally, these buildings had leaded glass doors that opened onto spacious front porches.

The Alwyne Lane Apartments
843 Alwyne Lane, Robert West, 1924, Flat Iron style

The Alwyne Lane is an elegant and airy Flat Iron–style building. It once had formal urns along the roofline. The urns may have been removed in 1958, when the city cracked down on deteriorating cornices. A *Detroit News* article from December 21, 1958, reported cornices falling off buildings in downtown Detroit. The previous June 24, an elderly woman, Myrtle Taggard (eighty), was window-shopping in downtown Detroit. There was a roar, and pieces of a large cornice came down, killing her. Five days later, a falling cornice barely missed Police Sergeant Theodore Gould at Woodward and Elizabeth. About a week later, a falling concrete cornice piece almost struck State Senator Charles S. Blondy in the 8300 block of Linwood.

There were other reports of near misses over the next several weeks. Charles E. Allen, deputy commissioner of the department of buildings and safety engineering, said that since Taggard's death and the date of the article, his department had issued 1,663 cornice violation notices. The

Alwyne Lane Apartments, 843 Alwyne Lane, designed by Robert West in 1924. *Photo by Allan Machielse.*

problem of falling cornices and decorative trim on office buildings in the downtown Detroit area is still a problem. There have not been any deaths but many close calls. In addition to the loss of the urns on the Alwyne Lane, the Cumberland Manor (700 Whitmore) lost its Juliette balconies that had graced the fourth-floor front apartments of the two wings. Evidence suggests that there was only one other apartment building of the Flat Iron style in Detroit, and it has been demolished. There are office buildings in this style throughout Detroit. We can compare this early work of West's with 980 Whitmore and 950 Whitmore, which are just down the street. If you stand in the plaza at Alwyne and Whitmore, you can see two phases of West's career.

900 Whitmore
I.M. Lewis, circa 1950, Art Deco/International style

This building was designed in a transitional style where Isadore M. Lewis was moving from Art Deco to International style. Compare this building to 850 Whitmore and 825 Whitmore, both by Lewis. The building at 850 is next to 900 and across the street from 825 Whitmore. The screened balcony is an example of an original owner's apartment.

Lewis applied for membership in the AIA in November 1942. He was born on May 5, 1886, in Appleton, Wisconsin. He was also licensed in New York and Washington, D.C. Lewis graduated from Appleton High School in 1906 and Lawrence University in Appleton, attending 1906–07 and 1907–08. He was a graduate of the University of Pennsylvania in 1911, earning a BS in architecture.

Number 900 Whitmore Road, designed by Isadore M. Lewis circa 1950. *Photo by Allan Machielse.*

A streetscape looking west-northwest on Whitmore Road from Alwyne Lane. *Photo by Allan Machielse.*

A streetscape looking west on Merton Road from Woodward Avenue. *Photo by Allan Machielse.*

His professional training was in Chicago, first with Otis and Clark and then Shattuck and Hulley and finally with Carby and Zimmerman. He practiced as an architect on his own in New York in 1937; Washington, D.C. (no years given); and Michigan from 1911 to the date of his AIA application. He was accepted as an AIA member on March 6, 1943.

The Sonoma
1000 Whitmore, Weidmaier and Gay, 1928, Moorish Revival style

This buff brick building stands at the intersection of Whitmore and Manderson, with the entrance on Whitmore, which ends there by joining Ponchartrain Drive. The Sonoma is a riot of decoration, with gargoyle heads and the kind of decorative brickwork in the window elevations that we have come to recognize as the stamp of this firm.

17535 Manderson
architect unknown (Ira J. Spoon, builder), 1950, Moderne style

This is a two-story orange brick 1950s rendition of the Moderne style, featuring large multi-panel windows. The entrance has a large porch covered by a metal canopy. The canopy is supported by a concrete formation and metal poles. The entrance door is wood and set back and enclosed in a wood frame with patterned glass. The main porch is flanked by two private porches with wood-framed entrances.

Shelbourne Apartments
17765 Manderson, architect unknown (Sam Satovsky, builder), 1947, Moderne style

This is a two-story yellow brick building with a landscaped courtyard and private porches with decorative metal railings. The main entrance exhibits Moderne styling with double wood doors between glass block walls. Its styling overall is similar to 17535 Manderson.

AFTERWORD

The Palmer Park district has been home to many communities. The GLBT (Gay, Lesbian, Bisexual and Transgender) community had a strong presence in the district. Within a mile radius, there were seven gay bars, a gay bookstore and three gay-friendly restaurants. The intersection of Six Mile and I-75 was within a mile or two, so there was quick access to the entire city. The census of 1970 showed 3,099 residents. The 1980 census showed 3,105 residents, up to 60 percent of whom the Palmer Park Citizens Action Council estimated were gay. For the GLBT community, the district was a protected zone where everyone was free to be themselves. For a complete history of the GLBT community in Detroit, I recommend Timothy Ford Retzloff's "City, Suburb and the Changing Bounds of Lesbian and Gay Life and Politics in Metropolitan Detroit 1945–1985," a PhD dissertation from Yale University, written in 2014. This exhaustively researched work tells the story of the district when it was "our village" to the GLBT community.

With Temple Israel at the west end of the district, many of the surrounding buildings had large Jewish populations. Many apartments near the temple had mezuzahs on the doorposts well after the temple congregation moved out. There were many Jewish supper clubs, like Menjo's, that invited all to dance the night away. Madonna partied there before her "Material Girl" days. The temple is part of the northwesterly migration of the Jewish population of Detroit until now reaching far northwest into the Bloomfield Township and West Bloomfield areas. There are stories that Al Capone was a customer at Menjo's when he came to Detroit to meet with the Purple

Gang. This was the Jewish mafia, and they controlled Detroit and the Detroit River, which many bootleggers used as passage to Canada since the river was narrow at this point. So when Capone wanted to do anything in Detroit or on the river, he had to deal with the Purple Gang. There are no pictures or any information on which to judge the claim of the gang leaders meeting at Menjo's. It may just be one of those "interesting" stories about the area.

A Note from the Author

I hope you have enjoyed your trip through the history of this often overlooked section of Detroit. Many people have told me that they've come south on Woodward and seen a few apartment buildings bordering the public park. But they are amazed at the quality, style and grace of the district once they get a chance to experience it. I find myself a little frustrated. I cannot find the words to describe to you the vibrancy, the color, even the joy of living in this district. I frequently tell people to watch *Tales of the City*, Amisted Maupin's show based on his books about being a gay man in San Francisco in the 1970s and '80s, his great love song to San Francisco. This was the Palmer Park of my day. Mouse, Maryann and Mrs. Madrigal were my neighbors.

When I finally left in 1991, I went thinking I would never see the park again. It would go the way of the city of Detroit and decay into a ruin. I did not go through the area for about ten years. I did not want to see the death of my home. Then, I heard that a new group of people from the area had come together to renovate and save the public park. I joined the People for Palmer Park and recognized the kind kindred souls. I began to conduct my historic building tours, and we have had as many as six hundred people on the second Saturday in October each year.

There is a story I like to tell during the tours: it was the mid-1980s, and I was living at 980 Whitmore. I had a large one-bedroom apartment with large windows and hardwood floors. It was in the front of the building and had a balcony. I was sitting on the balcony in the early evening on a Sunday.

From somewhere, I heard a flute playing. Then, I heard one of my neighbors join in on the piano (there were four baby grand pianos in the building). I listened to this gorgeous music for at least fifteen minutes. Then, it gradually died off. I never knew who was playing. The story may seem romantic, but I think it typifies the kind of aura, the kind of life that was Palmer Park in that era. Whether the park will endure the forces of change that have sunk other communities in Detroit is always an open question.

INDEX

INDEX

ABOUT THE AUTHOR

Gregory C. Piazza is retired from a fundraising career in the nonprofit social services field. For the past thirty years, he has volunteered his time as a historic tour guide for Preservation Detroit, Palmer Park Citizens Action Council and People for Palmer Park. A resident of the Palmer Park apartments district from 1974 to 1991, his research led to its designation as the first National Historic Places District covering half the buildings in 1980 and served as the basis for a second designation in 2005.